THE HOPE OF FLOATING HAS CARRIED US THIS FAR

STORIES AND PHOTOGRAPHS

QUINTAN ANA WIKSWO

COFFEE HOUSE PRESS

MINNEAPOLIS, MINNESOTA

2015

Coffee House Press books are available to the trade through our primary distributor, Consortium Book Sales & Distribution, cbsd.com or (800) 283-3572. For personal orders, catalogs, or other information, write to: info@coffeehousepress.org.

Coffee House Press is a nonprofit literary publishing house. Support from private foundations, corporate giving programs, government programs, and generous individuals helps make the publication of our books possible. We gratefully acknowledge their support in detail in the back of this book.

Visit us at coffeehousepress.org.

LIBRARY OF CONGRESS CIP INFORMATION

Wikswo, Quintan Ana.

The hope of floating has carried us this far / Quintan Ana Wikswo.

pages cm

ISBN 978-1-56689-405-0

I. Title.

PS3623.I49A6 2015

811'.6--dc23

2014033361

PRINTED IN THE UNITED STATES

FIRST EDITION | FIRST PRINTING

ACKNOWLEDGMENTS

"My Nebulae, My Antilles"—first published in *Gulf Coast*

"On the Sofa in Vilnius"—first published in the *Kenyon Review*

"The Delicate Architecture of Our Galaxy"—first published in *Conjunctions*

"Cap Arcona"—first published in the *Drunken Boat*

THE HOPE OF FLOATING HAS CARRIED US THIS FAR

this book is dedicated to

Nihilists Romantics

CONTENTS

THE CARTOGRAPHER'S KHOROVOD

When she writes to me as she did before, at first there is the incomprehensible sound of crickets, and then there is my familiar smell, a scent released from my pores as dark and full of longing as they were before.

She will not allow me to write the first letter of a certain month anywhere in my correspondence to her, she says, because that letter always reminds her of the month that followed December.

But she says I can talk to her of anything else.

I write to her:

So be it then. Rules being what they are and what they become. Knobs have been twisted, settings recalibrated.

I don't know how to refrain from reference to that month, from employing the letter that brings me closest to her. It is the darkest one, the longest, the most bereft. Frozen. Perhaps because here in the far north, it is also black: we rise to the dark, we labor to the dark, we yearn to the sound of the dark without stars. The sky releases snow, as though it has run out of light and can only produce the temptation of constellations, descending to touch us with a silent ice that bites.

I remember the glow of red coals singing in her fire.

She is not here because I chose otherwise. Existence is the conse-
quence of consequence, a nested series of events that unfurl them-
selves with all the inexorable exuberance of spring. This is what
you planted; this is what now springs from your soil. And each
year I must look on, aghast, as the lonesome bright-green sprout
leaps forward from the blackened soil to remind me of the seed I
cast there long ago.

It was the darkest month, the one she forbids me mention. People speak of prison, and they mean an enclosed internal space with no exit, and all is hushed with apocrypha of insanity and solitude, the slow, sharp shock of punishment for crimes. But mine was real: it had bright lights and restraints, a concrete cot bearing a load of inconsequential mattress, wire mesh and iron bars and an enameled toilet, an aluminum plate and mug. In the hallways, howls or laughter.

In the daytime, questions. In the nighttime, questions. Some from others, most from myself.

What did you do that brought you here?

Whom shall you betray?

It was rumored that I had entered, and that I have never left.

I met her in December. That month is allowed to me. The letter D, followed in succession by E and C and E and M and B and E, then R. Again, a chain of action and reaction, a studied progression of letters that carry meaning. I walked down the street alongside the Baltic Sea. There was a night fog. I had risen to the dark, labored to the dark; I yearned for the sound of light, of stars. My friend said: *look up, there she is, standing at her door.* She was clothed inappropriately for the weather. A thin dress the color of frozen skin. Her hair was wet. She was tall but small; she was slight but immense, a naked tree in winter—all dark, half-broken branches in fierce defiance. She was emptying a teapot into the gutter. She looked up and, fingers stained indigo with ink, swept her hair from her face, and it was a December face stripped of leaves. She was bare. Luminous. I was one hundred paces from her, and I stumbled. She tipped the teapot and scattered its contents in the street. She looked down at our fate and it was winter, and then spring, then on with the sorrow of late autumn turning golden flesh into a scattering of dust. One hundred paces later, and we arrived at her door: sweaty and soot black and wrapped in winter wool, and already repentant.

Inside, singing, and the glow of red coals in her fire.

The consequence of consequence.

Her establishment, everyone said, was a place of easy pleasure. I was told we were stopping there for a meal, a drink, a turn at the piano, some tobacco, a body to flip over, enter, and toss back. Yet in the fetid swamp of war, she commanded a more distant island, unassailable, within a larger body of water.

Upon arriving it was clear to me, at least, that hers was an ancient place, some Sapphic temple defying exorcism, an immanence of incantations designed to alter the course of the engagement.

On a broad, stained table in the back, she drew maps in perfect ink on spotless paper, and their confidence felt ominous. She insisted she merely held the pen. She insisted hers was a simple teahouse, even as her skinny, steady hand marked the lines of what was and what is, what had been and what could be, and what might and what will never change.

Huddled in the candled pools of table, those I knew through the highest levels of diplomacy and intrigue consulted her scrolls of paper, remorselessly inscribed with thick etched lines of mountain and ravine.

How to traverse the untraversable.

How to surmount the insurmountable.

Double agents, assassins, provocateurs: for these denizens of insurrectionist associations, her teahouse led to plots of rebellion, victory, or defeat.

She lived thusly with these combatants and she recognized me immediately.

In wartime, there are but a few roles: champion, coward, enemy, ally, fraud. There are merely a few places: field of battle, hospital, brothel, grave.

She seemed at once to know me for who and where I was.

Today I receive a letter from her. It's difficult to sense whether she writes now in search of reunion or remuneration. I owe her something, but it's impossible to pay the bill: a debt whose compound interest accrues in decades must perhaps remain eternally unsettled.

She writes to me:

The coastline of this island is more than six hundred miles, and there is much to be explored. Often, both rescue and recovery expeditions alike require cartographic innovation in celestial navigation. The sextant measures the distance between any two bodies in a field: it can be of use whether or not bodies are stilled, or still moving.

She is not here because I chose otherwise. She is on a distant island, in a larger body of water than mine.

She continues:

Like your clockmaker, Hanuš, and his astrolabe, sometimes blinding is the consequence for leading a mission off the map.

They are relentless words, springing forward from the spotless paper to remind me of a seed I cast there long ago.

I admit: I wrote to her first, late this past summer. I sent a message to her by a courier who knew a courier who had heard a rumor of her assignment. At first, she did not respond.

I had written:

I think of you often, and am surprised to discover you are still alive. A new level of surprising: strange things happen. I hope you are and have been fine.

Surely it was inadequate. As though she were ever fully alive. As though she could have been killed.

Five months later she wrote back, on translucent vellum inscribed in a portentous brown ink, which she suggests is distilled from the oils of local nuts. I can envision her, the augural stork of her body plunging knee-deep through the frozen forest on a distant island, wrenching nuts from the desolate birch trees and crushing them amid the glow of red coals in her fire, extruding their sap as her emissaries.

A research expedition: wherever she is, surely there are scheming men or the massacred, inert bodies of them. Hers is the consequence of consequence.

I write to her:

Snow is falling here again, the sky quickly shifting from light, wintery blue to steel gray, and then a wall of snow, a snow cannon as they call it, a snow cannon from Russia. The language, as always but even more so in this case, speaks for itself.

I live in a house these days, outside the city, too close to the North Pole, so the snow that falls here stays. It covers the ground, the houses, the bushes, the trees. Everything is swept under a blanket of pure-white snow. Sounds become muffled and indistinct, and the cold makes people hesitate.

In the mornings, I take my sons out into the field to teach them the prints of winter prey.

We smell the air and it smells of her—it reeks of the consequence of her.

Sweat gathering in the hollows of my arms and back and chest—a sharp, sour scent of a sacrifice I long to make.

I teach my sons to recognize the marks of the wolf, gull, musk ox, owl. Hers are not here because I chose otherwise.

But for a moment, I think of showing the boys how to identify her print in the snow: toes like the points of knives.

Sole of her foot like the flat of an eyeless fish, steam rising from the mark as though a pot of tea had been emptied into a gutter.

It was her husband who first brought me to her house.

On leave from the front, his bar was the first stop for soldiers of discernment. His offerings were not insulting, but neither did they present onerous demands of any kind.

He attracted commissioned officers, well-placed plunderers, ambitious clerks—those with a need to feel elite, yet of the earth.

To feel the reek of something small beneath one's nails and then wash it off, and know oneself superior to it.

He was connected in the highest places. He could not be crossed.

Mercenaries came to him and gave what he instructed them to give.

She had already left him by that time, of course—many said she had tried to kill him with a butcher knife. That she had hunted him for days, her steel blade glittering for his blood, her fingers slashed with marks of her own making. That he locked his door against her, expecting her to break it down, chop it up, burn it away. But she pitied him, and moved on.

For others, the prevailing belief was that she had done this thing because he tried to beat her. That he needed to be master of the key and the lock as well. That she had risen up in refusal and rebelled.

Some believed it was because she had lost respect for him: soon after the war began, when it was clear he would evade the fight—he was content, it seemed, to sit out the war as a profiteer and panderer. A purveyor of distraction, games of chance, a ready assortment of unconvincingly legal alcohols, substances unpermitted and unrationed. He was a master of diversionary pastimes. He knew people in the highest places. But she had risen up in righteousness and repudiation.

After leaving him, she opened her own establishment.

She was a madam, they said.

Nearly all believed that she had opened a brothel: all dim lights and red walls and everywhere sites to recline in velvet red and soft as a vagina.

That with the proper phrase, the knowing gesture, a visitor could unlock pleasures beyond all possible mythos or imagination.

It was likewise intimated by a small and well-placed few that hers was a front for the resistance, a secret meeting place for strategists and tacticians who schemed with sympathetic armies to the west and east.

She, they said, was the cartographer, making maps of what was and what had been, what is and what could be.

All for acolytes to follow: to victory or the grave.

Her husband told me all these suppositions were untrue. That she left him for no reason, and set up for herself a place with no name, no purpose, and no profit. That she was enigmatic, and capricious, and incompliant. But pretty.

He rested his thick and strangely swollen hands on the bar and said, *She is not here, but I would have chosen otherwise.*

Now, on the nights he was not working, he often visited her establishment. He took me with him.

She was in Chinatown, and therefore off the northern man's map of reason and familiarity. Streets couldn't bother to be marked. The rules governing transportation were inevitably obscure. Dogs ran in cannibal packs, pausing under sulphurous streetlights to take a bite from their colleagues' leg or back or tail. Headless chickens dripped limp from hooks along the alleyways, their faces crushed into some nameless, sour delicacy. Childish faces glowered from windows, laboring on uniforms and implements for the war, a few lingering outside, bent over captured crickets, creaking, tethered by silken filaments inside miniature cases of gourd and wood. Totems for bravery and resurrection.

We hurried, and he urged me to look for the bands of yellow light streaming from her storefront windows.

This is where I think I've already said all there is to say. The cracked yellow teapot in her hands, leaking its dark brew into the gutter, steam ascending into the matted tangle of her hair, streaks of black on her face from eye to eye, two thin shoulders cold as bone, a long pale face with a slash of mouth, pointed teeth, a cadaverous hand tipping the pot of tea into the gutter to release the steam into her face, a thin dress inadequate against her narrow hips, shivering in the winter alley.

A lock of hair dripping behind her ear, she reached to tuck it back again with a half-blue claw. She looks up at me, plunging my way forward through Chinatown, and sees me for who and what I am and says: *Come in.*

And I did. A safe house. The glow of red coals in her fire.

He minded, terribly. He minded that I entered, and that I never left.

He minded that I stood in my boots on the deep, soft sofa under the hot red lights and sang hard, sad songs to her with no purpose, to no profit.

He minded that I drew the hair from her eyes and lit her face with curiosity and hope.

He minded that I knew her rules.

One week passed, and I hadn't left.

Then two.

It was rumored I was on assignment, that hers was a house of espionage, that she had secrets, that the resistance was gaining strength, that we had united for some grim purpose of freedom and liberation.

It was rumored that she had let my hand fall upon her breast, that she had let drop her knife, that she was revising her most unpromising maps, that we read to one another by candlelight from childhood legends of troll and fairy, that we threw wild mushrooms into the soup, that I allowed her to comb my hair and braid the strands around her neck, that we twined together as close as wires in a fence between what was and what is yet to be.

Three weeks passed, and I drew water for her teakettle and emptied it into her open mouth.

Four weeks passed, and ours was a house of love songs, a house of pores, a house of rapturous follicle, a house of rosewater, gunpowder, secretions, and saliva.

Ours were the secrets of specimens, of lost worlds, of cartography and longing.

We had kindled and gained strength.

We were united.

It was rumored that I had entered, and that I never left.

He minded terribly.

He knew—for I had once told him—that I had a lonely, clinging companion in the far north, in winter, in the dark, and our two children, and excuses and disappointments and evasions and thwarted escapes. He knew my hands were vainly grasping at the edges of that lightless coffin, where the lid could fall and crush them.

He came to our Chinatown door with a butcher knife. He hunted me for days, his steel blade glittering for my blood, his fingers slashed with marks of his own making.

I locked her door against him, not expecting him to break it down, chop it up, burn it away.

It opened, but I refused to fight.

And he didn't pity me, nor move on.

At his behest I told her: *I have been called back to the war, to behind the enemy's lines.*

She said: *We are all needed in our way.*

Silence fell between our mouths. Yet in the basement her printing press rattled, heavy with ink, duplicating rudimentary field maps of existential insurrection. Instructions for the revolutions that must surely come. She seemed next in line to be arrested, yet perversely unassailable.

I said: *I can tell you everything, afterward.*

She said: *I believe in you.*

It was the last day of December; the streets were slickened with sleet. All warmth was snuffed out, extinguished, as though in retaliation for its impudence.

I told her: *I want to marry you. I will return when the war is won.*

She said: *I love you. I will wait for you. We are all doing what must be done.*

Her husband arrived at our doorstep at dinnertime to take me away. He and I walked to his saloon. I sat down, and he served me soup and spread the cards. I laid my money on the table. The girls arrived, and the beer.

This, then, was my call back. These my enemy lines.

He said: *I will send you home to your duty.*

Not to my children, blond and fat; not to my mate, loyal and kind. I thought of poison. I thought of lies. I thought I should be punished and then forgiven. I imagined my death behind enemy lines, more filled with longing for myself than for this spouse. Broken, forgetful, demolished, I imagined a distant victory, ascending into the matted tangle of my true love's hair, streaks of black on her face from eye to eye, two narrow shoulders cold as bone, a pale face with a thin slash of mouth, her half-blue cartographer's paw that touches who and what I am and beckons me: *Come in.*

I said: *I would rather go home to yours.*

The glow of red coals in her fire.

She is not here, but we would have chosen otherwise.

And then he summoned his men and they arrived, and he showed me to them for the spy I was, and I was gone in a flash of detention.

Prison, through four more long years of war.

This, then, was my call. These my enemy lines.

The consequence of consequence.

I sat down in their house of chains, and they served me an ominous soup and spread the questions on the chamber's table.

Who are you? they said.

What is this you have done?

What did you do that brought you here?

Whom shall you betray?

It was rumored that I entered, and that I never left.

I write to her:

There's a constant smell of burning wood in the air; someone somewhere, or rather everyone everywhere, is trying to make the winter go away. A kind of delayed khorovod, but with fires for the living rather than the dead.

Let the dead fend for themselves, it seems. They can light their own fires.

Perhaps they do.

She writes to me:

In the far east, sailing the waters on a recovery expedition, in winter—snow on the shores covers the depressions in the surface of the sand. When walking on the shore, the snow looked strong enough to hold until suddenly—up to the ankles, the knees, the hips in these holes, plunging down into these deep, elongated holes. So soft, one couldn't resist falling over, then lying down, a good six feet below the surface of the frozen winter shore. As if buried, a body, snow blinded, below the shore. The perfect length for a body lying down, these long, soft holes. Lying there, in the snow in the graves, snow covering the long-moldered bodies of our dead.

But it was white, very white, and quite soft.

I gather her letters together in a string and keep them in a place where no one will look. These secret specimens of lost worlds, of cartography and discovery and longing.

After I was taken from her, I intended to return.

At first, captive by her husband, a blackmail master. His raven on a bar, its thin claw wired to the post. A chain on the money box, locked beneath the table. His wedding ring, speared by knifepoint to the headboard.

And then second, held captive by his connections. Arrested as a spy. Months in prison. Stalactites on the bars, bats above my bed.

It was rumored that I entered, and that I never left that prison, but—broken, forgetful, demolished—I quit it, and my promise to her, and I went back to what had been before: my sweet blond lover in the far north, our two young children, the fermenting honey of my beer, not knowing tea, or gutter, or the sound of narrow hips shivering in the winter.

My sons enter the room, half frozen with the cold. They complain: there is a crust of chalky gray in the fireplace. I blow on it, and there is no red beneath. It is dark here.

I write to her:

You are not here, but I would have chosen otherwise.

There are wild birds here, despite the cold.

In the mornings, I play with my sons. Ten years have passed, six since the war ended. Once again, it is the month whose first letter she will not allow me to write, because that letter always reminds her of a certain month, this month—the month that flees December, the month I was to return to her, but instead went north.

I write to her now:

I will return when the war is won.

I cannot speak to her of the months that followed our December. It was the month the war ended. It was the month she waited, and I did not arrive. Now I am a winter creature, blind in the far north: I rise to the dark, I labor to the dark, I yearn through the sight of a dark without stars.

She writes:

The graves so soft and bright, I suppose the soldiers couldn't resist falling over. Falling over, then lying down. Broken, forgetful, demolished: behind the enemy's front lines is an infinity of possible paths that a moving body follows through space.

A curve that a body describes. When they fall in battle, the bodies are stilled. The consequence of consequence. I find the point of light reflecting off their bones in snow and sun, and I mark it on my map.

The candle flame bends with the movement of this ship. We are all needed in our way. I have raised anchor and aweigh from what was and what shall never be.

Now I write to her:

Ita semper. So be it then.

Here in the north, in winter, there is a crust of chalky gray in my fireplace. And I blow on it, and there is red beneath.

AURORA AND THE STORM

On the first night, I set fire to the tops of the standing trees—ancient mangled things of meat and bone and torn bark. I had hoped it would bring some help, some assistance.

I waited for the branches to burn.

Some signal—they smoldered and released a greenish smoke of water vapor that I hoped would drag the sky for miles. Yet instead it returned to me, curled and supine in a defiant smudge. I drew it into my lungs and spoke through it, saying nothing.

Trails of gray from my mouth summoned no response.

Ravenous. Whatever it is, this thing, here, the leaves are all stripped from the few remaining trees.

Seven branches of the tree are gone, and so is she.

The second night, I continued to call for rescue, but there was no answer. I walked what's left of the upper halls with the severed cord in my hand, speaking into the transmitter.

In the ballroom, the crystal prisms dangle at dislocated angles.

There will be no sun in this place.

On the third night, the geese streaked by in a Roman phalanx.

They are girded and from below, without weapon, I know that what lies above us is merciless. What lies below crawls hungrily inside the frozen soil.

The birds navigate between.

Along what's left of the horizon, the lines of earth seem soft, but on the fourth night, the soil is burnt to dark charcoal: in the earth, branched red veins of ore that still sizzle in the damp.

I pretend the empty openings here in the walls are filled with glass.

That when I look out into the wilderness, I am looking through something, through a translucent pane that separates me from the beyond.

But it is not so.

There has been a change in pressure, and a collapse. A skin diver's lung, or a chambered nautilus too far into the deep.

There has been a shattering, and now all is softness.

Mist.

 Fog.

 Mold.

Snow.

The powdered wings of weakened insects that, like me, are unable to find shelter on the inside.

The air itself is milky white and cloaks my head in stripes of gray.

We have been swallowed by the storm, nacreous.

The sky is opalescent, as though I have become the pupil of some great eye, the night its lashes. Closed in a wet, close, muscular darkness that will not lift or blink until the shock of morning, when all turns opal again. My own eyes, pale and responsive, fill with the wet of salt that is not tears.

Yesterday, I walked to the edge of the terrace of the old hotel, where it begins to crumble over the ravine and what was once the rock garden, now an ocean.

A falcon's nest savaged by the winds, hanging in strips of birch bark and gangrenous moss.

That black bird an umbrella—an armature of wings upended and split back.

The feathers floated on the water, a life raft for mites, then moored themselves on a log, or a beaver's corpse.

My adversary is the Norway spruce. Each needle is an antenna urging me to leap into the white, and swim. But I know it is the sky. I have seen the savaged falcon. I know the ruse.

Each dawn, the spruce. Its unlikely tenacity through this storm means fat pods still hang from it, thick and swollen as sex organs.

Stronger than the wind that stripped all else to root and bone.

It says to me:

Leave that place. Join me out here. Climb into my branches. For your pillow, a hornet's hive. Press my sap into your blistered skin.

Whatever will become of me, of us, in this place without mark on a map?

As a child, my mother would unfurl the sailing maps from other ages and point to the inaccuracies of coast and continent—apocryphal places that loomed or tumbled out of reach of any vessel.

See, she would say, *they were wrong about everything. Our world doesn't look like this at all.*

The maps were kept in a metal trunk and locked. They belonged to her ancestors. They were records of their glorious mistakes. Their vast errors in judgment. Their utter ignorance about where they were going—and also where they were. They strode out hugely into lands with the confidence of curiosity and false knowledge.

Here will be a river. Here we will drink. Here we will find shelter. Here we will plant food for winter. Misled, unprepared, foolish, and naïve, they planned heroic feats for blood and nation, and were crushed. The first surprise was their error. The second surprise was their demise.

Yet their coded blood passed along the lines of centuries, down to this small daughter in new woods.

One day they will say:

There was a woman here, Aurora, who wrote in turbid prose. She kept a journal. She wrote in a hand of decreasing size as her paper ran out, and then her pencil.

She claimed that the pain of this land hauled itself up in a clotted wound from the earth itself and clung to her shoes, then crawled up and ever upward until it reached her heart, and then her brain.

In the night it glowed, a crown around her head with jewels that were neither sapphires nor diamonds.

The need now is for routine. In the journals of my ancestors, there would have been notes on the minutiae of cleaning and repair: as their voyage progressed farther off the coasts of an unwanted home, they would have compressed themselves into the dignity of work: A brass lantern to be rubbed and shined. Splinters carved from the wooden hull and fashioned into boot buttons, bored out with knife tips and threaded with string wound from their own hair.

Yet here I sit, cross-legged, knees pulled up to my chin, wondering how high the waters will yet rise: the fire and the storm cleft this place and left it bare as bone.

There are no tasks but this.

I am rendered mad: some lapse in sense or wisdom must have drawn me here, rather than a valiant and unquenched thirst.

I have followed a woman into the wilderness.

I have crept and danced and cajoled some rigid, slender, saddened form that has vanished in the storm.

Or was swept off.

We arrived here together.

We had our work. We had been assigned to a project on the dark matter detector. Our paper had to be finalized, revised, rewritten, and that is work to be done apart from the calcified structures of human civilization. We had boxes of notes and archives and conceptual matrixes of theoretical expansion points.

We had shipped everything ahead, and everything waited in our rooms in cardboard boxes.

In the hot damp of late summer, the boxes softened into warm shapes that promised nourishment, like brown-cottoned breasts in a nursery.

All day we worked, each day.

I roamed the buckling old hallways of black wood, my feet in wool socks and pencils in my hair, writing notes in my sheaves of paper. In the afternoons, I walked barefoot into the distant gardens to sit with hummingbirds and—later—fruit bats, and burrow down into my thoughts.

Her in her room, red carpeted, windows of diamond pane, uncomfortable chair, bad light.

A dark head bent down in an arch of neck that proved impossible to sustain: blinding headaches. A wrenching irregularity in alignment that at night I would want to rub out of her, but couldn't.

My body was a stone.

It lay heavy in my bed, and no one disturbed the dust that had settled there by morning.

Although I disguised it well, I'm certain that I hated her. She was abrupt with all whose paths crossed hers. She was thoughtless and unkind. Anyone who might advance her some slight interest or affection—no matter how mild or insubstantial—would soon recoil with the sense of having perpetrated an unforgivable violation. That to notice her was an intrusion. Yet I had arrived at our arrangement from within a state of great magnanimity: a year of professional success. A season of scientific awards, rewards and prizes, and I felt the world should profit by my gains. I wanted to pour wine, to draw out others in conversation, to elicit confidences and quiet confessions in the moonlight.

She knew it in an instant, and recoiled.

At the hotel, all guests were requested to dress for dinner and sit at a common table. The settings were fastidious and punitive, as though for a dour banquet or a funeral repast. The napkins: suitable for surgery, or requiem. I laid mine on my lap, half expecting that the dinner knife was meant not for plate but viscera, as though I would rise with a lap of blood and feeling faint.

She invariably arrived late, or not at all.

After several weeks of working together in tidy isolation, she and I had met far beyond midnight in a quiet corner of the upstairs library.

She did not disguise her disappointment at seeing me, or her certain horror at my approach.

I needed a pencil. She had none.

I don't recall why she spoke to me—it was perhaps a desultory command, or a clever condemnation of the lighting, which someone had left on for safety in the hall.

I turned it out, and in utter darkness she began to speak.

When I say that she spoke, I mean it was a gently thorough inquisition concerning my life up until that moment. Her questions were too perfect, too complete, with an eerie accuracy and unfailing specificity concerning the most unspoken details of my cosmos—as though she already knew the answers to her queries about my past and was merely practicing good science, meticulously cross-checking footnotes upon exposure to a new cache of primary-source materials.

Although she was leading me through the discussion, I felt I was imposing on her closely manicured time. Yet whenever I shifted my weight to escape, she inserted another question, and the shock of its uncanny knowledge pinned me there, perplexed.

The temperature rose in the room as the night wore on, and my clothes felt as though they had bonded to my skin.

As though blood had dried them into a wound.

I next remember lying on my back in the dark. She no longer sat against the wall, in a chair, sprawled out, improbably long legs and feet penetrating the shadowed room.

I was in the middle of the library.

The bookcases swept up thick and tall above me, sentries arrayed along the border wires.

In my field of vision were my knees and feet—had I fallen from a sofa and been unable to rise?

My great-grandfather's role in the asylum had been to split the walnuts. In between the fascia of their meat rests, a hardened, charcoaled matter that must be pulled out with a pick. That is how I felt. The fissures of my brain exposed to air, ready for consumption.

It was morning and I felt ashen, happy, and rearranged.

The next night at dinner, she arrived on time and sat beside me with aplomb. She poured wine. She offered a second slice of roasted chicken. She answered our companions' modest inquiries on direct detection, dark matter, Enrico Fermi, and what lies beneath the Dolomites in gallant, expansive form.

When I gathered my napkin to leave, she rose and pulled back my chair. *Perhaps a walk?* she said, and we went out down the staircase, across the ballroom, through the foyer, and into the woods beyond.

It was nearly a week later that she blushed. And as the blood rushed her pale skin and ruddied it, I felt a kiss form within my mouth and travel down through my throat and viscera and down further, to where leg meets leg in my most tight and demanding place.

This is the shape of love: a V of care that widens from a finite point, or narrows from a gulf into a well. It is the bottom of a funnel, a cone, a wedge, a fang.

I became alternately wild and bashful. I avoided all contact, then sought it mercilessly. I began to smoke cigarettes. I stopped drinking wine.

I sat in my room of red velvet chaise and wood desk and white sheets and watched the insects gather on the lampshade.

I walked the woods for hours in tight shoes.

I turned my memory of her face into a puzzle, rearranging it until I could forget the angles of her eyebrows, which at dinner would arrange themselves anew. She would pull back my chair, and again we would follow our past footsteps into the future.

We would talk toward dawn, a corpuscle flush in the horizon that brought chills and wind and wanting, and we would come in from our woodland walks, and all would begin again.

It was at the height of our happiness that the old hotel announced a change in weather. A storm approached.

The geese flew overhead.

Mice crawled into the walls to die.

Bats infested the vaulted ceilings in the breakfast rooms.

It seemed severe, the approach of winter, or was it hurricane, or something worse?

Those of us intent on survival quickly took to the highest floors.

She and I found rooms that had known no occupant since the last century.

We gripped the wooden balustrade, whose ancient beeswax gripped us back, layered and layered, attracting touch.

Oil lamps lay shattered on the carpet, drowning the startled mites barely extant from another era.

She was beside me at times, or I thought I could see the nimbus of her head in the rain, but I would squint toward nothing solid.

The water came first, then the wind, and then peculiar colors lit the sky: magenta, chartreuse, crimson, tangerine.

All the colors war casts upon horizon, but this in the night, through no human hand.

I stood on the balcony.

I wanted to be taken, but tied myself to the post in hopes she would find me there.

Or did the lightning arrive first, its skeletal electric fingers cracking all along our bones, spying out our soft places?

And next the rain?

It battered us in unlikely geometries—wet lines of angular momentum that unlatched windows and doors and smashed them. It took our curtains and clothes and sliced all raw. Exposed, we crouched there, swollen and pliant in the water, our spines and ribs left alone with the work of shelter.

Then came the wind, wise from the lightning's reconnaissance: it found our seams and split them.

We toppled and gave way.

What folly, architecture.

What futility is a wall.

Hallelujah.

The others died like cattle: crushed, drowned, half-knowing.

Hers was not among the bodies.

I buried the rest.

I knew.

My red room mildewed to a pink in the beginning, then bruised black and green with mold.

Next my bed, infested with spiders, celestial navigators come to harbor from out of the floodwaters.

They charted star maps, constellations of red bites along my flesh.

As the waters rose, I climbed higher.

In the attic, my next bed was soon overtaken by mice.

The damp mattress half barrow, half burrow, writhing in a dank mass of furred bodies. On Sunday mornings, teeth nibbled my toes. At hours that once marked sacred time, my flesh became a new communion.

Rats left their droppings along my dresser top.

I first mistook the delicate black fecal whorls for tea leaves; I soaked them in standing water and found them bitter.

And the waters rose and took that room too.

Centuries hence, and two girls could come through my ruins and bow their heads into the gloom of a reflecting pool.

They would know of the hotel, the storm, the broken heart, the world's near end.

That future pool is blackened, shadowed; they do not find me there. Their faces glow, distorted through the surface.

The typhoon rose toward me in a spiral, offering ascension.

Yet I stayed below.

When I arrived at the hotel, my hair was black, my skin was smooth, and my toes were crimson manicured. When these future girls come to visit this place, green ferns will have unfurled along my fontanel.

What fertile skull have I, that allows such snails safe mooring?

These toes, webbed, gelatinous, fused with scale and fin. We first were gangrenous, then all went liquid: a relief, at last, to abandon castle and become moat.

It's impossible to talk of sadness here. Any remaining sense of self must survive unarticulated, decomposed, in shapes and lines that once formed words, but since the storm have unfurled into threads that stitch my layers together, connecting inside to outside and back in again.

I withdraw and emerge in unbounded states, with edges that cannot be marked and meanings that cannot be defined.

A barred owl passes by the rooftop at dusk and flies away with one of my mice. It comes back again and takes another.

Regardless, there will be more tea in the morning.

I have wondered in what nest this evening hunter rests: there are but few trees, half-burned, and this eviscerated hotel. All else is mud and sea and roughage. The raptor carries bits of meat that had been claws, brain, thigh.

I braid my hair in a circle on the top of my head and fix it there with sticks. I am ready for a crown of claws, of horns—to take lessons from a predator.

I want the owl to mistake it for a nest and land there.

When the waters took the highest bedroom, I broke through to the roof, with no time for provisions or supplies. Now my pillow is wherever I gather my hair into a bundle and sleep.

Orion takes aim at my closed eyes. I open them for the hunter, and she comes riding in.

I beg the imagined rescuers: Don't come for me here. Don't look for me with your bright spots of dry light.

I don't want rowboats, flares, blankets.

I want earth, pebbles, broken branches.

Stonecrop. Roseroot.

Porcupines.

My love.

Years have passed since I walked with her through her book of questions in the wood. No, it is not years, but moments, days. I can sense she is here, inside the walls themselves, inside my walls, that there are other lips on the side of this delicious cup of tea.

Where is the one who knows the questions? At night, I dream in answers, often in sunshine—the sun an orb driving pins of light into my hands, and I wake in pain. I have not seen that yellow planet since the rains.

My flesh nocturnal, my pigment secret, my sight wary of illumination, and I have the soul of a newt.

The nose of a mole. A starburst of pink in the middle of what was once my face.

The shell of a snapping turtle shipwrecked on my roof, picked clean of meat by seabirds, by the single kingfisher that takes all the fish we reach for.

I peel the black resin off the turtle's bony shell, and it becomes a helmet, a bowl, a drum.

I should fill it with blood sacrifice.

Below the third floor, the eels have arrived. They are languid. This their sanatorium. They have left the confines of the formal garden, their prison of cistern, and swim through what was once their sky.

Now it is they who reside in the best rooms of this hotel, and I who crouch in my bounded space, captive, dependent, ill at ease.

Should I fashion some harpoon? There is no meaning here to anything but hunger. I am eclipsed by need, and grow thinner by the hour.

I have become a hibernaculum: the eels have found me. Their scarlet tongues taste my breath as they rest in limpid coils of black and yellow, long lines of sex and ease that defy my human loneliness and anxiety.

They are cool to the touch, and hard as an erection.

If they slipped through the waters and found but me, am I the only shore?

Every living thing has a water tale.

What mythos of creation leaves out aquatic devastation? A lesson meant to teach a humble stance before the cosmos's mirror.

Even a birth begins with water, breaking.

Even the daffodils speak, hushed, of the spring when the creek splits its seams.

And yet this event unseats me from these stories—I am thrown down, gasping, knowing I have no value to whatever delivered me here, unwanted.

When I lie on my side to imagine sleeping, I watch the stone roof swell, the pale slate tiles bulge outward in thick pops.

This roof, my room, turns from a place of hardened angles to a kind of angel, a fleshy place of pale white with freckles of brown.

But it is not her.

The rains come down lightly this time, as though offering armistice, or apology.

When I lie on my back to imagine sleeping, I feel the tiles rise up beneath me as the waters below ebb and flow.

I rest on a great rib cage. A racket of bone and flesh with heart and lung expanding and contracting. It seems I can smell another's breath. That the wind, once cold, is warmer.

Only the moon has not been torn from the sky, and it illuminates the pearl of this place: a roof goosefleshed, prickled, and suddenly sprouting frond and root and stamen.

So now this, a lugubrious green; my arms are the leaves of lilies stretched across a scum of floor.

There are mosses sprouting from the hollows of my kneecaps.

They rest and gaze and pollinate.

Now the night has come again, the next in an empty sky of new moon.

I cannot face the chasm, and I lie on my chest to imagine sleeping.

This floor of my roof, my room, my universe, has grown soft and warm, and I curl into it, gripping its short green hairs in my fists.

Tonight, a new, soft plant rising up from a crack that grows wider in the slate.

The moon is new, and I am hungry. From the slate bulges up some kind of fungus, some sort of bud, as though the storm drove a wild spore across a thousand miles to reinter it in the flesh of this hotel.

In the endless dark and damp, we are growing.

Have I lost the will to live, or have I lost the will to live as human?

See how thin I have become?

My wrists a gathering of sticks, my lips are lichen on a lake of stone.

Is she this mossy plant, nourishing—could I eat her raw?

No matter how I pull, it will not release from the wall. Despite my hunger and my strength. The walls themselves groan. The force of my will shall pull this place apart.

I take this flower in my mouth and swallow all her stars, and she takes my face and covers me with leaves.

There is a deep sadness that can sometimes be redeemed. When the sense that all is lost becomes unneeded.

When the lake is sky and stars offer themselves for fishing.

When inside mirrors outside.

When all is wet and wanting.

See here, I say to the emptied, merciful sky, *now you are the same as I.*

THE ANGUILLIDAE EATER

He sucks at my breasts and tugs my nipples, and—with one finger—presses down on the median of me until a single egg emerges from between my legs.

He smoothes the peak of my hairline and the sweaty locks around my forehead, leaving a residue of my oil on his thumb that will stay for days.

I am exhausted but will return to the ridge to watch the ships.

A tall, narrow spritsail, mainmast sprit-rigged.

Reef point at upper edge.

Dawn.

He carries my egg in a waxed leather sack. It rests within a nest of dried seaweed, warm and chalky as phosphate.

Rain today, as always.

And later I will return, cold, from the ridge at sundown and build a fire in my hearth.

As always, it will produce a black haze so thick my flesh itself turns gray.

But in its dark, gentle heat, I will let down my hair and pick it out quietly with a comb, the small bodies of my lice igniting with a hollow pop in the coals near my feet.

The men load caskets of eggs into the small boats and take them out toward the holds of the deepwater ships.

In the men's deep-floating, double-hulled ships are barrels of eggs packed in dried straw and brown algae.

Each egg the size of a fist.

Some with shells fierce as oyster shucks.

Some eggs, more fragile, have already broken open and begun to cloud, staining the crated hay a viscous black.

I scrub at my teeth with a handful of sand, and pick out the grains that lodge beneath my fingernails.

I sit, knees crossed, on the low ridge above the shore, watching the men standing tall in their sterns.

Jib tacked to stemhead.

In the mornings, the flat boats leave the shore low to the water and tie up a while at the ships' sides at high tide, then return, lightened, to be tied up again at shore through the night.

Night will fall, and at shore the empty boats will float high at low tide.

Their heavy daytime waterline of stained oak and barnacle raised in the moonlight.

Dark falls charcoal on the sea.

The ships anchored far out of reach.

Orion.

Cormorants.

The sailing men are on land with the women.

The ships are anchored far out to sea.

The small boats are empty at the shore.

At dawn they will again be filled with eggs.

He returns.

My skin is smooth and pale as duck fat.

He returns—

I am more fierce than wolves.

I have clawed open seashells with my fingers, then crushed and
eaten them.

I have honed my teeth to points with handfuls of sand.

He harvests the egg with his tongue.

He leaves with my egg in his bag.

When he stands shoulder to shoulder with the other men and packs my egg into the morning barrels, mine is the pale lichen white of young fangs: slightly luminous and unbreakable.

He looks down at a sea pinked with blood.

My bed is filled with crow feathers.

He returns.

We leave my bed together at dawn, and I leave the door open for new air.

I walk apart from him toward the morning shore.

When we reach the water, we move in opposite directions.

The man, with his purse of egg heavy at his thigh, is expected at the ship.

He retraces his footprints backwards from the night before.

I walk apart from him toward the south, holding my iron eel rake.

At times I stop to loosen tiny pebbles with my toes and examine them for size and smoothness. I warm them in my palm, then knot them into the hem of my blue dress.

The man's odor still carries to me from the north.

It echoes the scent of his thumbs on my forehead, and along my spine and thighs.

I find my usual inlet for eel—a calm place where the sea snakes linger in the silt below seaweed. It has taken them thirteen years to travel from the Sargasso to nest in these cold northern waters of the Baltic.

Untying my rocks, I swallow them.

I will wade in—then dive—and sink heavy in the shallows before scything out an eel with my rake and pinning it to a tine with my hands.

Small. Rough.

It arches up and twists, tough, but I wring it, and its spine stills after the crack.

I will walk back alone with my catch.

A thin fall of blood streams from the eel, its skin cut from my rake.

I will lay a bed of seaweed over the gray ash and pinecones of last evening's fire, and later add shavings of rue, birch, linden. My eel steams and smokes as the sun rises slight above the dunes.

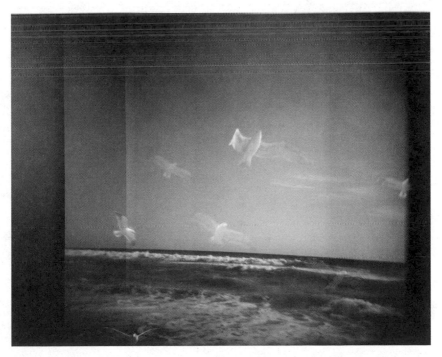

The men stand high in the stern with their barrels of eggs. I can pick out mine by his silhouette. It's a private matching of night man to day man, and it happens in the ducts between my eyes and the insides of my skull and chest and hips.

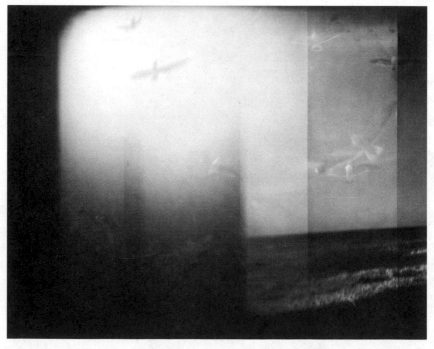

The smoked eel is not yet stiff in my fingers.

My throat holds the taste of war and liquor.

A stone settles into my uterus with the lowering sun of afternoon.

It will turn a young green inside, form albumen, form a yolk of mold and gold muscle.

Soon as dark falls, the sailing man will come, coax it from my pelvis, then raise anchor, and away.

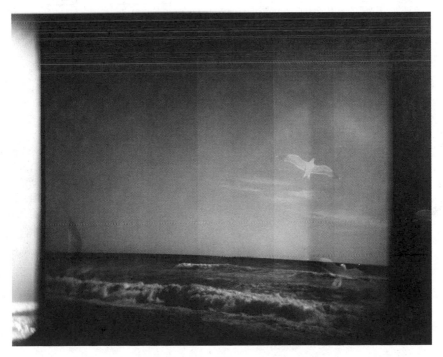

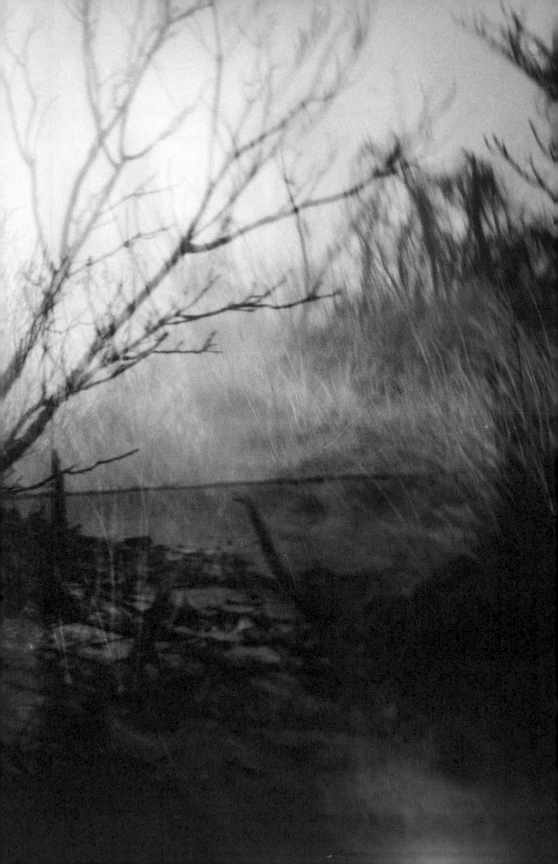

HOLDFAST CROWBITER

Like the others, her legs are heron stalks. This is another way of staying unmarried besides war: she is poor, and she is not fat. When she crosses the dunes, she leaves holes instead of footprints. Standing hip-deep in the Baltic, her thin limbs don't disturb the waves. But she is young and her teeth are strong, and the crows die in her mouth with a flap of black feather.

Our world a punctured lung that contracts and expands without ease. What is close comes near, then billows away far from reach. So much is evacuated, then all is spasm, and gashes, and wet tissue.

Where there is pain, there is a gasp.

Our rib cage a cleaved accordion, the organ no longer used for lovemaking. The air we expel is stale with fear.

Please don't pick up all those rocks.

Pray to be turned into a blanket, a hat, a pair of socks: anything that comforts.

Pray for what now gives way, that it some day hold.

Pray that the dunes will stay around the roots.

Prayers for bones that bend instead of break are prayers for our bodies to be soaked in vinegar, pickled, unable to expire.

Pray for good winds. Pray for calm seas. For our immortality.

As often as possible, pray for something that does not exist.

Give promises that predict a new kind of orifice, something that opens and closes in a part of the body that is currently undiscovered, through which something good emerges.

A body mollusk—as though there are pearls waiting inside us. As though our poverty of spirit is only passing.

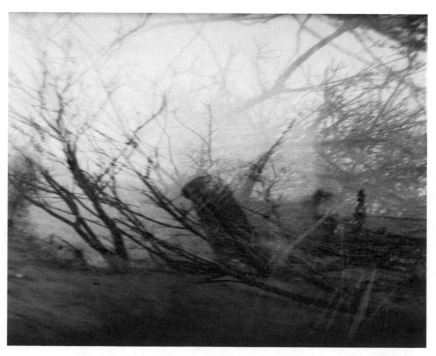

Please don't take away all those rocks.

Like the men who sailed off the edges of this sea and fell into the void, there are areas within us that contain a precipice.

Start collecting sticks and cloth. Learn how to wrap them for a shroud or sailcloth.

We are using them for ballast, for the time when the undiscovered has at last come into view.

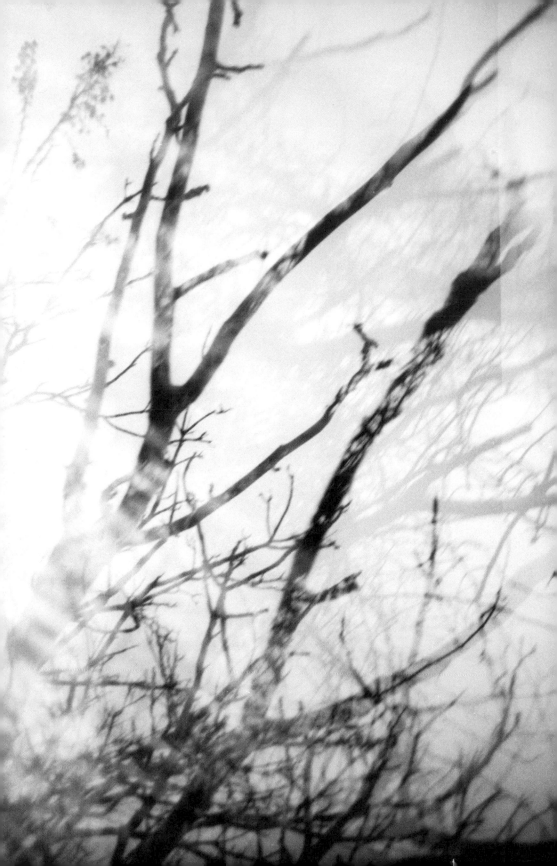

Consider these Curonian woods a pincushion, if possible. A soil pricked with pines that climb straight up. Everything poised to hold together. The sands only half bound upon the earth, impermanently affixed.

When the winter comes, we stitch ourselves to the dunes with pine needles.

The trees have nearly no branches, yet still the wind whistles through their wooden teeth. A seducer's song, meant for the winter sun.

What an armisticed romance: how can the sun come down, when everything here is sharp enough to kill?

The Baltic sun is distant, but wisely, because it is wary of what comes with a descent.

She has gone fishing again, and in this tide she struggles, thin legs wrapped up in that thick, wet pelt of bladder wrack. Whole belts of it broken loose: the sloughed-off spongy muck of a uterus at new moon. The vesicle cysts close by, for buoyancy, for surfacing.

What a tangle, what a mess of trumpets and vines and the kind of crying that accompanies a split of sinew and tissue: saline.

Death, birth, what of it? The insides have come out. The disgust is in transition, both the coming and the going.

There is one tame crow that sleeps in the attic eaves. She came and took it, and fed it meal soaked with liquor until it fell asleep, compliant.

The crows now sacrifice themselves to the women. It is a way of saying thank you when there are no other gifts to give. Because the beets ran out, and then the beans.

Her bag—a pouch—some sort of textile tension that suspends a burden, the crow. Later, on the plate, they will place this burden into themselves, suspend it in their gut.

Today the rain, an inverted sea, a mess to get through it. Cold, painful—despair in love with gravity.

Up there on the hill is an old woman. She is a human horseshoe, pried off the battle-weary hoof and lost, rusting. An osteoporotic woman oxidizing within the saline mist. She stands on the heights of this dark mound and watches for ships that do not come.

Her every finger an apparatus cocked for curing—tumors, sausages, curses.

The old woman stands at the deep square trenches dug along the coastal forest ridge. These fortifications seem the graves of some geometric god. They are filled with mysteries for killing.

If such weapons pits house a furied god, who made this land his altar?

Underneath the flap of skin—let's call it a tear—where inside something's flickering. A rip in the epidermis: embroider the membrane. Decorate the opening like an about-to-be bride. Make it a grandmother stitch of doilies and faded daisies. Beauty woven through disaster. Pull each thread of it tight and nick it with the teeth. Just a snip of the lips so it's white and wet.

The mouth is a pocket of wind and wanting, and also of words. It smells of a mother licking its young. One tongue or two, accommodating. Just a flip of muscle, a flap of skin there we call a cheek, the sag that goes taut with shrieking.

She is so hungry, she uses the side of a fish for a mirror. She isn't divining the topology of her features, or longing to confine the sweetness in her fleeting greed: one silver fish and laid against it a pair of late potatoes and a cut of bread—in its shining sides, the tubers become four, the bread a loaf.

Pike. Herring. Beans.

How it feels in winter, eating only what is white.

When the end is near, gather close to the old woman. Become small as sand, and cling within her wrinkles. Later, some will say, *Oh, they have built a hut of sea-washed wood along the dunes. It guards against the sand attacks. It is a house made for old women.*

Forget this. When the end is near, gather close to the old woman, and be gathered into her arms. Be wrapped by her legs like the loved is wrapped by lover, like tree by vine. When the end comes, it is bone, not wood, that will protect us.

We have so little to work with here. We live in houses where woman flesh erodes from bone. Climb inside a woman, and wait for her bones to build a house. Her arms and legs the pylons.

Look, we have built a hut of sea-washed woman along the dunes. It is a house made of old woman.

In the summers, the green snakes once slept with us in curls, fresh as ferns. They were as much among us then as men whose hands were for creation. The crows slept safely in our eaves.

There were moments of still, once, where the tide pulsed within its bounds of vein or dune. The linden tree, the birch, and the rue grow roots to embrace the buried.

There is another way of staying unmarried.

The girl has not returned from fishing.

The bees weave a thatch of wax, and with them it sticks, collects.
Whereas with us, all is precarious: we leave holes, not footprints.
A fletch of salt-soaked crow bone in the sand and silt.

MY NEBULAE, MY ANTILLES

Let's say she lies all day on a beach in the Antilles, and I embroider her until she becomes my buttonhole: a silken stitch with needle and thread of seaweed. I slip through her skin of sand and cashmere, as though a pearl fastened tight against the rise of her flesh.

This letter from the Antilles tells me of progress regarding her strategic plan: to wrap a series of single square concrete blocks in colorful stripes of spun sugar. To artificially inflate the price of artisanal fishhooks, and profit by controlling the market for radial netting, handspun by a sisterhood of leprotic Haitian nuns.

Her tactics remain vague. This discussion incongruous, superfluous.

What of our more esoteric conversation?

Why now this intrusion?

I wrote back to the Antilles and told her to cease clarifying her schemes for artistry and insurrection:

Why now this inclusion? What of our sartorial distractions? Please—tell me nothing of what you did today, of what foods you ate, or of your fragile frustrations.

Let us go diving in a different sea.

Let us stay down so long we come up with barnacles, with gills.

I once overheard one meat-packer whispering to another on an eastbound train:

When I was a small child, I was very silent. I was known for my silence. It was not known that I kept a diary. In its earliest life, it was a simple count of the day's activities. Tally up the scabs on my kneecaps. The sixteen colors that live within a beet. As the days passed, I learned that paper listens. And later, as I became more courageous, and my life took on a more uncertain meaning, I began to talk. Secrets of the sort spies are trained not to divulge from within the calibrated agonies of torture. Exquisite. You might think a young child would not have secrets of those means, that capacity to heal and to destroy. But I urge you, reconsider. There are intimacies some are inclined to pursue against the wishes of a silent child.

It became clear my house was unsafe for the keeping of this diary. We lived in a remote area many miles beyond the nearest town. When I could escape the range of civilization, my companions were foxes and falcons, tigers and weevils. They read only the language of the senses. They lacked thumbs. Safe, I placed my diaries within a series of large glass jars and buried them. Each week, another jar.

We were far from the cultivated fields . . .

Although the train car was quiet and my ears unusually sensitive, I averted my attention for some time.

Not from delicacy, but because I believe in the ethics of eavesdropping.

One false choice, and the luminosity of another person goes dim.

The letter—the next consecutive letter, highly anticipated—remains delayed. Weeks pass.

New magazines arrive from my agent in Riga. I read them.

Latvia is only a distraction. The way home is a hole at the center.

I dislike the wind in Riga, and the sound it makes against the buttresses, whose angularity and rigidity are merely concealed by the distracting romance of cleverly carved vines and furbelows.

Ah, Riga, all your sands have long since turned to stone.

It was winter when I fled to the Antilles. This was many years ago. I remember I was exhausted. Three months I planned to stay—no more, no less. Solace.

I rented a room in a house that proved unsettling. There were reasons they rented to foreigners. Even the local children knew why birds would not land on the tower balustrades. Why the floorboards had been painted, and why the cracks so very carefully filled in. Why the aloe grew thickly along lines of nonexistent pathways, and why the lizards refused to cross into those furrows.

Because of this, and through the desire to change the habitual patterns of my fundamental inclinations, I spent my days and nights on the beach, or under some wide-legged leaf.

The language barriers proved significant and insurmountable. The islanders had never heard of my country—my every attempt to gain legitimacy failed. My willingness to show them my passport only underscored their suspicion.

Despite their conviction, I had nothing to reveal: many meetings began with speaking and ended in the extended silence of stalemate.

So becalmed, there was little to do but learn to evade these predicaments altogether. I ceased all social activity. I ceased moving about the island.

With thin and inconsequential new data, my brain began to relieve itself of a lifetime of congestion.

In isolation, memory after memory unfurled themselves for mere instants—their dendritic fronds arrayed like firecrackers against my darkened sky.

And I, a slack-mouthed bystander, gaping wide-eyed from below.

In dread that these memories would rapidly reconstipate themselves within my mind, I decanted them onto paper, just as the meat-packer had suggested. But unlike the meat-packer's urge for burial, I wished to push them from myself—to set them into movement, to hurl them outward.

I began posting several of these as letters to myself.

Each day at the post, a familiar charade: the scrambling quest for communion, the ego's thirst for false impressions. A performance pantomimed for the clerk.

These must be on their way at once

They are already terribly delayed

Someone is waiting for me back home

I never had sufficient coins in my pocket for full postage. This invoked ridicule, or pity, or censure. Someone always helped with condescension, as though making some oblique religious argument regarding my insolvency.

Refugee, drifter, panhandler

As the weeks passed, the claw I stretched across the government trestle was not mine; as I wrote through the winter, the skin on my hand gradually dried and cracked—a result of the climate, and the length of time spent writing near the microscopic spray from the surf.

Even the fingernails were iodined, archaic.

I probably posted four or five letters each day.

I endured the many long flights that brought me home, and my skin again softened and smoothed out, but it was as though my travels to the equator had altered the passage of time.

As though some spine had risen inside me along which time nestled, like a dune.

When the letters began to arrive, I had been home for nearly six months.

I found I had no memory of writing them.

I barely recognized this woman, their writer.

Despite all claims of dry, hers is a damp heart, and pounding.

As time passed, I remembered her less and less, yet knew her more and more.

Is she who I was, or who I have yet to become?

What harbor harbors her?

The equatorial sky above her is so unlike my sky of roof. Concrete, I-beam, tar, shingle, chimney, aerial, contrail.

The letter arrives. The delay: I have misspelled my own name.

How easy it is to lose myself through administrative error, or through the foibles of sloppy typography.

The lunar curl of half claw, shaping an ill-lettered alphabet.

I move through my world half-phantomed. As if to perhaps avoid myself, in all locations.

Today's communication relies on the preposterous.

She writes:

I am reading a book about the native crustaceans of the Antilles.

I do not recognize the characters as letters, and thus when I read, I fall asleep.

In this way, I have learned nothing of the crustaceans of the Antilles.

Yet when I am asleep, I dream: I am a crab nebula.

In this way, I have learned everything of the crustaceans of the sky.

Her distance from me in time and space remains a question due to uncertainties in every method used to ascertain her existence. Clearly, however, her presence is expanding outward. Within days of her creation, she could only reach to the end of her pencil.

Then to the government postal office, and no farther.

Whereas now, her words find me on the other side of the earth.

She writes that in the Antilles, there are two methods for reading fortunes:

First, one must set a basket of crabs on one's bare stomach and deduce the future in the bleeding scratches.

She spends afternoons in this pursuit:

Their remarkable chelae equip them for mastery of a uniquely delicate lexicography. In fact, the sea floor is a dictionary of unprecedented accuracy and eloquence. It has made me eager to learn how to swim. I ask the fisherfolk to teach me, but they refuse. They say anyone who gazes for too long at the sea floor is beset by madness. I asked to meet one of these aquatic lunatics, and the fisherfolk obliged. But again, I encountered a language that is not my own. The lunatic gave me a basket of crabs, and indicated that I should set them on my bare stomach. The remainder of her instructions I deduced largely from context and innuendo.

She feels no pain as scrying tablet for the crabs.

The crabs see an end to machines that inhabit the sky: airplanes, spacecraft, satellites, and that perplexing muddle of invisible vibrations that comprises our telephony.

She says the crabs offer an optimistic presagement of some great reversal of sea and sky.

The crabs tell of an immense starfish with sweet-fleshed, swinging scabrous arms who cuts through it all—they call it Sea Sky Spider, or She Who Tears It All Down.

She says their new god, they say, *will keep swinging until there is nothing left.*

They see an end to these aerial boxes of commerce.

Afterward the sky will be white, a transparent vista of clean crème nothingness, and the crabs will come from their nebula to scratch out a new vista.

She writes that this particular lineage of crabs dates back to the Jurassic—they know certain things to be true.

They have long memories, which are interrupted only by cookery.

And they do feel pain.

There exists a clever implement for the construction of egg salad. Within a plastic and aluminum apparatus lies the quivering egg, unshelled. It glistens, and then its moist promise of birth evaporates, and its opacity takes on a dullness, and the metal wires cut through the cataract of it until the core dawns golden, a sort of morning glory, edible.

This is what these letters do to me.

It's surprising how many of the letters become lost along the way.

I suspect letters are now so uncommon that anyone encountering them cannot resist the compulsion to touch. It begins with turning the paper over, feeling the paradoxical oily crispness of its skin.

The translucency.

The temptation that enough handling can provoke a sentient response in the envelope—as though the proper caress will cause the glue to soften and yield, the flap to curl up slightly at the edges, and then with a gasp, the sheet of writing paper within will begin to simply swell out of the opening.

All of it happening with a fluid muscularity.

A year of waiting for another letter. For months my patience was my testament of valor. This my monument to trust.

And now, a year—I have seen the sun glisten off the bodies in the water, and how hard the ships must work to overcome that beauty, much less the surf at water's edge. Perhaps the letter never left the island.

What else could be the cause for this delay?

A shipment of lemons waiting on the tarmac in Miami, flies on their stems, soon to become citron pressé in Dijon, and at the bottom of the crate is wedged my letter. An indigenous rind fungus has eroded much of the paper. The pulps mingle and rot.

My letter sits in a stamp shop in Tangiers, being fondled by the inventory auditor.

There is saliva there that is not my own.

I am betrayed.

The letter arrives—a full year has passed since the last, and I had assumed the letter lost. And yet here it is.

Initially I am delighted by relief, but soon I sense a coldness at my periphery.

It creeps up closer and closer toward my heart, closing its trapdoors in my veins along its way.

There is no hope for thawing this one out.

The thought of betrayal has created a spiny matrix, rather like a window screen, and the sweetness I knew before bats its wings against the barrier in vain.

There is no entry here.

I write:

Where have you been? I waited for you.

My landlady has begun sidestepping any introductions to new tenants. She used to like to make matches among us—arrange for petty romances and gallant rescues in one direction or another.

I hear her whisper:

For quite some time now, Apartment 42 has been having an affair with a woman in the Antilles.

I'm not sure what's wrong.
They never visit one another.
The phone is silent.

Sometimes months go by between letters, and it's nothing but gloom and despair in there.

No need to worry. It's surely harmless.
I suspect there is a moral issue that stands in the way.
People can be so small-minded.

Another letter arrives. Inside, she says:

Yesterday, I ironed all the tiny pleats in the indigo blouse, your favorite one.
Due to the humidity, its encounter with the iron was erotic.

I write back:

Yes? But did you repair the button?

I already know her answer. And before I have mailed my response, her reply arrives.

Inside, she says:

I refuse to repair the button. I am adamantly opposed to all indications of time's passage. Instead, I sleep with it between my teeth.

She writes as though ours is her second language.

I worry that she is skating across the surface of what really matters: survival, accomplishment, security. She is adapting her brain to fit this attractive new reality, rather than adjusting reality to fit her understandings and beliefs.

I worry that her lifestyle of sun and shade renders her little more than an incarnate sundial, telling the hours of the rest of our life.

Silent, immortal witness.

She sends me unrequested advice, willing me to take it to heart.

To make changes.

To alter course.

I worry that while she continues her life in the Antilles, seeking guidance from her crustaceans, the two of us are on divergent paths that intersected only briefly that winter.

I worry that our trajectories are tangential.

That if we ever meet again, she would be disappointed in who I have become.

Or perhaps at who I have continued being.

What if I were to become quite ill? The details of this sickness would be dull, but rather unpleasant to experience and observe.

I have little here that I would miss—a solidly admirable life, fulfilling, but surely not essential.

It's just the thought of her letters arriving at a destination that is no longer accurate. There would be no forwarding address.

I cannot imagine how I could get word to her.

She writes of the most recent epigrams of the sibilant crabs:

Above all else, cease from worrying.

Stop these tricks of the mind.

This, the greatest disease that prevents humans from evolving as a species.

It is worry that conjures weapons.

Recently, I was riding in a taxicab.

One of those weary, bleached afternoons that pretends to be a dawn. For a moment you indulge the light's charade—*fine, yes, you are morning, I believe you*. But the curtain closes on the game, and night surprises you with its applause.

That is the perfect moment for a taxicab.

I ducked my head. I climbed inside.

Oh, the beauty of that dark and greasy womb.

The foreign driver was listening to a contraband radio broadcast on a dashboard shortwave. It had audio subtitles that created a riptide of meaning—the reporter's fluid syllables slipping past the harsh rocks and reefs of our native consonants with disarming sanguinity.

Because of her sibilance, one might be tempted to jump into conversation with a vulnerability and earnestness one would never reveal at home.

It's dangerous.

One ends up pinned down somewhere, gasping, unable to breathe water instead of air. At best, one ends up carried away from where one entered, exhausted and very far from shore.

Nonetheless, as I sat in the taxicab, I listened to the reported scandal of the day, which pertained to the government postal service:

Its procedural manuals have not been updated since the third dictatorship.

The key postal facilities are replete with arcanery that calls itself equipment: cancellation machines whose pulleys are fabricated from human hair; slits and holes and slices in conveyor belts whose apparatus itself is suspended across a crevasse, at whose bottom holiday spelunkers claim to have found parcels containing scientific specimen trays of species long since extinct.

These irregularities have been going on for quite some time.

The journalist says:

A surplus of neglected mail so overwhelmed the postal service that it dumped more than a thousand bags into the water, creating a dam of undelivered correspondence dating back several decades.

Several large Fascist-era high-rise apartment blocks were flooded when the river leapt its banks.

The journalist says:

A rather magnificent New Year's Eve celebration was halted by state police when the confetti was discovered to consist of shredded holiday cards, chosen from the outgoing mail bins on the purely festive basis of colored envelopes.

Communist times.

Children crying.

Lovers irrevocably suicided along the nation's perilous embankments.

If only the letter had arrived, everything could have been different.

Would have.

I lie in bed at night and think of her.

I brush my teeth in the morning, and I think of her.

I know she found some sort of sextant and compass necessary for optimal navigation.

Everything that is missing in my life here in the North.

In the last letter, she provides me with the following:

There is a second method for foretelling the future.

It is as dangerous as it is accurate.

Precisely at midday, while the sun can cast no shadow, carefully mark your coordinates by drawing two perpendicular and intersecting lines.

Then—equally carefully—split oneself in two.

One is to wait in place.

The other is to go on ahead.

Through this method, it is imperative to maintain close and regular correspondence.

She is a buttonhole, and I am the button. There is nothing else.

THE KHOLODNAYA VOYNA CLUB

It is the first meeting. Our gaze is bleak, austere, and focused, yet our fingers chatter, skeletal, around crude ceramic cups: the force field of combat discipline weakens at our appendages at the farthest distance from our hearts.

Already the physiological deployment of resolve and commitment has begun to falter, has become less certain.

Our enemies are despair and shallow breathing.

The light in the room has shifted to glacier tints of ice and water, sky and eye. Our skin glints silver—more trout than human.

The coffee is tepid, and we barely sip it. It is our 342nd meeting.

There is a green gelatinous murk to the light, and our fingers only loosely wrap our coffee mugs, a drape of slimy flesh that suggests a grip.

At the crests of our heads, each bears adipose fat and the beginnings of fins.

The admiral strikes his fist against the table, and we snap into shape again: ankles, knees, hips, and shoulders emerge from sinuous spines, and we once more resemble ourselves, our former selves.

The forms that we recall, we rebuild.

We reach up with real fingers to feel our skulls, and find these sites reassembled. Sharply razored hair appears—snipped into a brush of platinum or ebony or gold, obeying appropriate military affiliations.

We clench our memories of torso and leg, and blood pulses at our jawlines.

This is the tactic we learned to keep from blacking out.

Although we could as easily seat ourselves by branch of service or by aircraft, in our earliest meetings, we instinctively calibrate ourselves according to ideology.

Geopolitical affiliation is at first divisive. There are sharp disputes, often erudite. The North Koreans confront the French. The Americans accuse the Cubans. Confusion mixed with cultivated hostility forms the basis of aggression. Repartee is offensive and unflinching. Often, we have killed one another—either directly or through a causal chain of events—and that escalates the tensions.

Most questions we cannot answer, and, stymied by the inexorable failure of dialectic, we begin to hit each other.

Our wounds get in the way.

We shyly coalesce into groups corresponding to fatal injury: skull fracture, stroke, drowning, asphyxiation, hemorrhage, burns.

This is what starts us talking about women.

We first remember arguments. Stubbornness, selfishness, recalci-
trance, and dishonesties on both sides. Lies told and retold, polished
and honed to a state of purity that felt like truth. Disappointments.

It's not as simple as recalling a name, a breast, or five proud, blue
bruises on a thigh gripped tight to facilitate lovemaking—the
memory of specificity intrudes.

A dispute in a rowboat at the park after eating a tin of spoiled oysters, the pilot and the lover both heaving over the sides into the path of an astonished mother and her summer ducklings.

She was going for a test at the doctor. Worried, the lover rewired the house and her hairdryer shorted out. She would never be authorized for another and changed to braids, which smelled of chamomile and licorice.

It was raining in Pyongyang, and the pilot went to buy her tampons—so expensive and difficult to find. She wore galoshes.

The pilot shared the same dreams with her at night, unconscious. Autobiographically accurate, yet identical. They had even dreamed them at the same hour, and woke together, crying. She drove the pilot so crazy, sometimes it seemed possible they were the same person. Perhaps a single schizophrenic.

Sun coming through the leaves in patterns. Buttercream frosting on her nipples for the pilot's twenty-seventh birthday. Pushing the old bones of the car home—the pilot shirtless, she barefoot. Mockingbirds. Lost keys.

It is the precision of love that startles the pilots. All the training at instrument panels and aeronautics controls—the muscles remember, but not the mind.

Our minds are mobiles strung with counterbalanced points of desire.

To wake with the smell of her under my nails. To hear her cursing in the shower. To find her short, dark hairs on my pillow.

For seventy years, the Cold War test pilots have avoided such sentimentality, but now we have exhausted all other agenda items for our meetings.

We have waited long enough.

We all went down in water.

With each meeting, the suggestion of gills becomes more prominent.

We seem increasingly ectothermic.

We call another meeting.

One pilot says:

It must be a question of where the body thinks it is. We are half human, suspended between spirit and purpose. At the moment of death, on impact with the sea, the wet itself seemed to want to take us and make us some other sort of species.

Nature abhors a vacuum, but it was love that held us back.

Why must we die, yet retain a mortal's desires?

Another pilot says:

Our final days as human ghosts are drawing to a close. Like radiation, there must be a finite period of time elapsed before our atomic matter is called upon to form some other thing. Fish are to water what pilots are to air. The transformation is as simple as that. Nature adores a pattern.

We must leave our loves behind.

We drink from our crude ceramic cups of unsatisfying coffee, and hide tears.

On this we all agree: We are fading away. We are lonely and far gone, and our true loves have doubtlessly moved on.

We have been training heavily. We can now pass through the air unimpeded.

No longer suspended in armature of aluminum and steel, we move without fuselage.

Without weapons.

We know we will soon fly blind.

We must now navigate by other senses.

At our next-to-last meeting, we find it increasingly difficult to make eye contact, or to successfully maneuver the exchange of coffeepot from one pilot's hand to the next.

Everything is bleached white and overexposed, with refractions of pale pink and lavender obstructing the crucial functions of our corneas.

It seems unduly cruel for our eyes to fail us; we are test pilots.

Or were.

At our final meeting, we certify one another good to go: we have done this before, when there were other vessels at our command.

Now there are no insignia.

No diplomas or medals or sashes or stripes.

There are no new hats, no special helmets.

Gloves and scarves and boots are useless. Goggles, throttles, thrusters. No bombs or rockets now. We counsel one another on the voyage: The Cold War is over. There will be no red borders, no blue. No orders or directives.

In all lands, the citizens will have left their fallout shelters to go shopping.

We descend in the night. Our women are sleeping—a shoulder above the sheets, a toe exposed. Hair tied up, or loose and tangled.

It is night, but the eyes of the pilots see only white and periwinkle gray.

We find our women by their scents alone: nicotine, citrus, rose attar, shoreline, lotion. There are nightgowns, or a ratty chemise, or nothing.

We slip through the windows, then along the walls and across the floor to stand there, dripping slightly by the bed.

The poor blind pilots.

When our women wake, they press their hands to the cold, flat flesh of these apparitions and cry out—they are guilty, lovesick, torn.

We the pilots make knees of bone and flesh again, and press them up between our women's legs.

We raise our women off the ground, pendent.

We are airborne.

I'm not dead, we the pilots say.

Speechless, our women find their tongues. They count every tooth before speaking, but find they cannot speak.

I'm here, we say to them. *I was never dead. I was never gone. I'm alive. We're together.*

It's a dream come true, and yet a nightmare. For we are dead, and our women have met others and moved on.

We follow our women's scent as they return to bed, as they entwine themselves with the living limbs of the peacetime beings who have replaced us.

One day, whisper we the pilots, *you will be dead.*

And we the pilots return to our aquatic, atomic states, and wait.

It is a line. A long vein of a line that barely moves. The queue for the afterlife curves toward a shrewdly engineered gate—a kind of vascular faucet that opens with an occasional gasp.

We the pilots locate one another in the crowd. We navigate and negotiate, and because we are test pilots and soldiers and confident with communism and competition, we are adept at clever stratagems that bring us ever closer to the front.

Whenever the gate opens, the crowd thickens and thins. It clots and coalesces around itself with vascular anticipation. One pilot rushes forward—*Is it her? Is she here at last? Did she finally die?*

There is a jostling for position, for vantage.

It is first come, first served. If another suitor gets there faster, it's all over till the next time.

The light has shifted to a crisp magenta. It is uterine—the color of both a birth and a sloughing off.

One by one, the women come through this passageway and find themselves deceased.

There is a kaleidoscope of recognition and recollection.

A pink prism of memory and longing.

She was going for a test at the doctor. The test pilot drowned still strapped into the cockpit. Her hairdryer shorted out. Ducklings. Hemorrhage. I had rewired the house. The pilot's cause of death was asphyxiation. The oxygen useless. She braided her hair the way I loved. She smelled of chamomile and licorice. She wore galoshes in Pyongyang in the rain. My skull was fractured.

There were oysters. Mockingbirds.

Rowboats.

ON THE SOFA IN VILNIUS

Her in heavy pants, thick waxed canvas work apron tied stoutly around her waist and chest, covered with paints and mud. Her son Leo doesn't speak—he's ten, and he has lost all his words, his recognition of her, and now his are the three dark scratches down her nose. In my bag, God knows what. A tin of charcoals, blackberries, a bicycle chain for repair. Summer. Around two in the afternoon, before the songs and shouts of children too early gone from school. After the deliveries, glass bottles of milk and medicines on dolly and trolley, precarious on the cobblestones. Her mouth on my nipple— it began with laughing. At the end of the hallway, the old metal door that sticks in the heat with old paint clotted on its hasps. A thick grate across its window, like it's braced for cheese, or a crowbar. Us on the other side, not waiting.

Enter the husbands in my mind, hers a blackberry, all curls and little seeds of eyes. Mine I pretend permissive, this a gift. I am an idiot, and this is where we belong, on this sofa, one foot pressed against the linoleum floor that later I will scrub. It's what I came to do. The bottoms of my feet black, my nails black grimed beneath; there are crumbs inside her shirt from the little one, unleavened. This is our hour. There is no magic for women in the morning— all is preparing, inventory, reminders, making ready for tasks, errands, disasters of blood and body and book learning. Clothing bought and sold, sizes adjusted for age, accounting for nutrition. List-making, stocktaking, coals in the oven, and where are the pencils to be sharpened? The knives. Brisket. When will the butcher be ready? For us, the afternoon, the hour of naps.

For an instant, I remembered our apartment—in a flash I emptied it—no tables and chairs and children, pots, towels, photographs, curtains—just a wide expanse of cream wall, four windows, and this flat, golden sofa, striped with lust and light.

THE DELICATE ARCHITECTURE OF OUR GALAXY

My mother lived in a mason jar. Twice daily, I took the lid off. She said it was to allow her to breathe, but she only seemed to dive deeper.

A theory existed, saying that her bones had one day become gelatinous, and she had slipped into a jam jar—an expedient, offhand solution orchestrated to prevent herself from sliding into the cracks between the walls and the grasses. Once in, it was too late. She couldn't possibly convey instructions for future decanting.

According to this theory, she had for many long and industrious years sought to understand the secret language of slugs. From within her internationally renowned laboratory, she had lured and cajoled the creatures up from their moldering depths through exhortations, incantations, and promises tempting to a gastropod mollusk. Once captured, she attempted to penetrate their enigmas.

Ruthless, extraordinary, and infamous, her research nonetheless remains unknown: she had always eschewed assistants, and her lab notebooks vanished or were destroyed.

Hers were precarious advances in the field of biological sciences.

There are several types of bodies commonly found in suspension.

On the solstice and the equinox, I would take her to the lake. She was prone to desiccation, and these quarterly pilgrimages proved invaluable. I would unscrew the lid, pour her into a butterfly net, and plunge her into the cool, still waters. The waters seemed black at first glance from the surface, but down below they were a bitter walnut yellow. The tincture stained her skin green and lurid for the first few years, but afterward it added a peculiar Sephardic luminosity to her flesh. As if she were lit from within with the born or dying sun she'd fled her jar to worship.

My mother at winter solstice:

During the winter solstice, I would have to use a pickaxe to break through the crust of ice formed on the lake. As I held her beneath the surface, the handle of the butterfly net would form complex crystals of frost. Delicate, as though it were trying to tell me something in a code of its own sharp language. My mittens would leave a pelt of wool along its surface, softening it. Each winter I worried that my mother, too, would freeze, and not fit back into the jar after I pulled her out. But this never happened.

According to one legend, a mysterious Hungarian hurdy-gurdy man—no poor busker, he—had arrived in my mother's town when she was a young woman. This Hungarian materialized in her meadow as though from nowhen and nowhere, as though conjured from an errant wormhole, dislocated from the familiar continuum of time and space. And through the Pythagorean drone of his soundboard, certain bystanders distinctly heard him offer my mother a sizeable, oddly luminous glass jar of watermelon pickles.

The rind was striped a violent chartreuse and emerald, with a shock of opalescent white and a thin grin of pink. Alluring.

She took the jar from him for the price of an irresistible kiss, and when she reached in her sweet fingertip, her world inverted.

In her place on the meadow were sixteen slices of preserved watermelon, saturated with vinegar, brown sugar, black pepper, and whiskey. In their place: my mother.

My mother at vernal equinox:

At the spring equinox, I know she enjoyed the baby minnows. Their small, even bodies existing as perilously as slivers of dream, half-silvered in the dim gloom of our lagoon. I would hear a faint cadence, like laughter, from the water, and many of the small, new ripples in the lake were caused, I suspect, from her attempts to catch them in her hands, or possibly her mouth. They must have been fascinated by her teeth, if she had any. By her lack of animosity.

Each year it seemed there were more of them, as though they waited for her. As though it was also some sort of holiday in their society, or perhaps some call to tzedakah. Thousands of them swam in and out of the holes in the butterfly net, it having been designed to catch things with wings, not fins.

Even through the distortion of several feet of water, I could see how they longed to touch her, their scales brushing soft against her flesh. Everything starting to thaw, beginning to warm.

In my childhood, I taught myself to read the Yiddish of my purported ancestors. I came across ancient tales that said my mother had been an extraordinary circus performer—a contortionist who had fallen in love with a glassblower, fresh from the seashore. Handfuls of sand, his hot breath, and suddenly, her inside.

A collaboration, a labor of love.

The rest was mystery, and artifact.

When we went out together, I would cover her jar with an embroidered cloth. Along the street, people mistook it for what is often used to shutter a birdcage and prevent the creature from singing.

Others said it was some kind of schmata or sheitel or tichel, peculiarly covering her jar and not her head.

Or a me'il, but covering a woman instead of the Torah.

They looked at us askance, unsure of whether to praise or to condemn, and uncharacteristically afraid to ask.

Her unspoken demand for this covering made me uncomfortable. She would not answer my questions about whether she was ashamed, or secretive, or perhaps merely reclusive.

They are very different sentiments, and it bothered me, this ignorance about exactly which impulse I was enabling.

My mother's hair was a gorgeous bright red—vermillion, even— and formed a rootlike webbing in several places. After a few years, it grew to a sufficient length and thickness that allowed her a more dendritic concealment of her form.

When I was sixteen, she developed tentacles. They were retractable.

This occurred during the period in which I began excavating the garden shed. I found a brief compendium of well-preserved old seventeenth-century music manuals dictated by a blind limyk and covered in an intricate, Byzantine lacework of slug slime.

How had they come to rest within our garden shed?

This nonetheless stimulated my considerable interest in the lute. After several days, I was inexplicably proficient.

It was during the times I played that her tentacles extended to nearly their full length. Once in contact with the surface of the glass, they would curl into spiraling tendrils, like fern fronds. Constant movement. Grace. This is how I learned that music creates light and scent that are imperceptible to traditional human sense organs.

When we went to the movies, we smuggled in several long strings of black licorice—they were sold to us by the Dutch children every autumn, who knew to offer us only their very best. I would lower the strands into her jar gradually through a small hole we used for this and similar purposes. I would hold the spool of licorice in my lap and let it slowly spin out through my right hand, feeling the hollow weight of it between my fingers as I turned the remainder of my attention to the film unfolding on the screen.

Over time, the string of licorice would unroll from its wheel, sliding through my fingers in quite the same way as the strip of film slipped from its reels through the projector.

We would spend hours like this in the dark—me consuming the story, my mother lovingly macerating the flavorful candy.

Treasured by Alexander the Great, licorice is actually a fertility-inducing legume.

Ah, cinema.

Another source of happiness for my mother was heavy rainstorms, but only when experienced from within the house. When I was younger, I thought she favored the cataclysmic rush of humidity and moisture, or that perhaps she experienced a bittersweet nostalgia for the pelt of droplets against her subtle flesh.

I fleetingly hypothesized that she fancied the thunder, with its astounding lack of chromatic scale.

As I became older, I realized her deep kinship with the windowpanes. Their translucence, their transparency against air and water, their mineral urge to separate and define.

My mother at summer solstice:

While summer solstice marks the day of greatest light, it comes early in the season, perversely preceding the days of greatest heat. Imagine if they both occurred at once. Imagine the levels of stimulation that would likely bring us to our own destruction.

We appreciated the ebullient young leaves, still emboldened by May's blossoms, as yet magnificent in the froth of arboreal mating rituals involving pollen, pistil, stamen, and bloom.

The bisonoric bellows of the bullfrog in his reeds.

The air at dusk actually whitening, as if with milk.

One morning I awoke to find letters etched on the surface of my mother's jar: מאדים: *the one who blushes*.

Who is this woman?

And why have I come to believe that she is my mother? Perhaps she is some god, and I her sibyl.

By sunset, the word had vanished.

For as long as my conscious memory can recall, I have carried and cared for this mason jar, for this woman inside the mason jar, for this being, my mother. I know the concertina folds of her fingers pressed against the glass, the arterial delta of her wrists. The alarming perpendicularity of her knees and nose and thumbs. The stitching of her spine, articulated within liquid.

I have fully accepted the nature of her existence from the outset, or so I believe.

Is she trapped? I may as well ask the blackberries in their pot of jam.

To all who understand the significance of her jar, she is absolutely caught in allusion to a fetus. Was I once similarly inside her?

What is she waiting to become? And how can I best help bring that to its fruition?

Or is hers a perpetual becoming, with no final moment of birth? She, the queen of the liminal.

My mother at autumnal equinox:

Cats have followed us down to the lake this year. They were the kittens of the spring, and theirs are the mice whose fur is the color of dried leaves, of stones upturned in a field following the harvest.

Her heartbeat swells and changes the pressure in the mason jar—the tin button on the lid plunges down, then pops up, then down again.

My mother is the source of other legends, which are concealed within a secretive arcanery that allows for few new pupils—these texts suggest she is an augur.

And apparently ancient.

According to the texts, she is directing the birds, the fish, the snails.

She is advocating for the perpetual return of the comets, whose tails she commands with genius precision.

Because of her, the absolute fecundity of a supernova.

When I plunge her briefly into the chilling waters of the lake, I finally understand. That which is most powerful must most comprehensively be contained.

For an example, consider the word: without its form, our utterances would be screams.

Today I crack the eggs for a quiche, and I think she looks at me, quizzically, as I strike each shell against the old tile countertop.

It fractures, and for a moment I believe I hear a gasp.

The shell in my hand somehow midwifed, as though delivered of that sweet parasite life, the zygote yolk and its mucus.

A Russian doll birth—a chicken purging the egg, and then the egg purging the yolk. Eventually the intestine and then anus purging the yolk, which is then purged by the pipes and then the sewer.

Sympathy for each unlikely oviduct. Each triumphant in their masterful final achievement: emptiness.

The shells lie bereft in the palm of my hand. Purposeless only because their purpose has been destroyed. Yet somehow, within the uselessness of the empty eggshells, their cracks reveal a glorious apparatus: a biological architecture of calcium and chemistry.

Derivative and reminiscent of the hivelike structures of Magreb nomads. A mineral womb bleached the color of bone and chalk and eyeball.

Here in my hand rests a futuristic cathedral. An anatomical geometry that startles.

The yolk as surprising as marrow, that something so soft and liquid, et cetera.

Just when I have tormented myself—wondering if my mother thinks me a murderer, if she imagines my hands on her jar at some future date, similarly splitting it, pouring her out into a drain or a pie crust—after believing nothing escapes the notice of my mother's highly perceptive intuition for metaphor and suggestion, I see that from her position in front of the kitchen window she is twisting and arranging her appendages within the jar to create shadow puppets, life in light against the white face of the oven.

A camel. A monkey puzzle tree. A quail.

CAP ARCONA

Karolina and George met at university. She studied ornithology. She thought George had the eyes of a bluebird.

George was studying engineering. They would read together in the library. They never spoke. She had books about birds. He had books about airplanes.

He admired the structure of her hands, which seemed to him like wings.

At night, they would dream of each other.

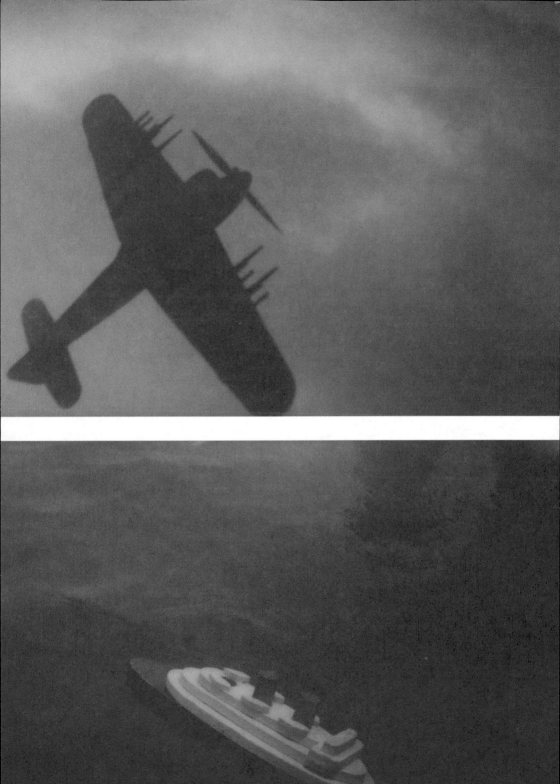

In her dreams, they floated on the river together in upside-down umbrellas, making wild and inventive love.

Precisely at the moment of orgasm, falcons would catch hold of their umbrellas, and carry George and her far, far up into the sky.

In the clouds, they would continue making love.

In his dreams, Karolina would give birth to enormous eggs.

He would sit on the eggs until they had hatched into birds with his aristocratic face and her delightful fingers.

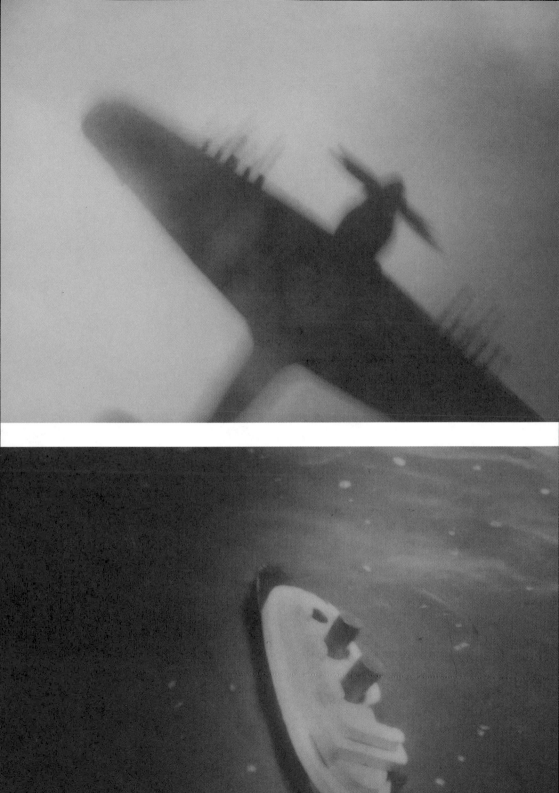

They never shared their secret dreams.

Instead, they continued to study together at the library, and occasionally the toes of their shoes would touch.

After graduation, they promised to meet again soon.

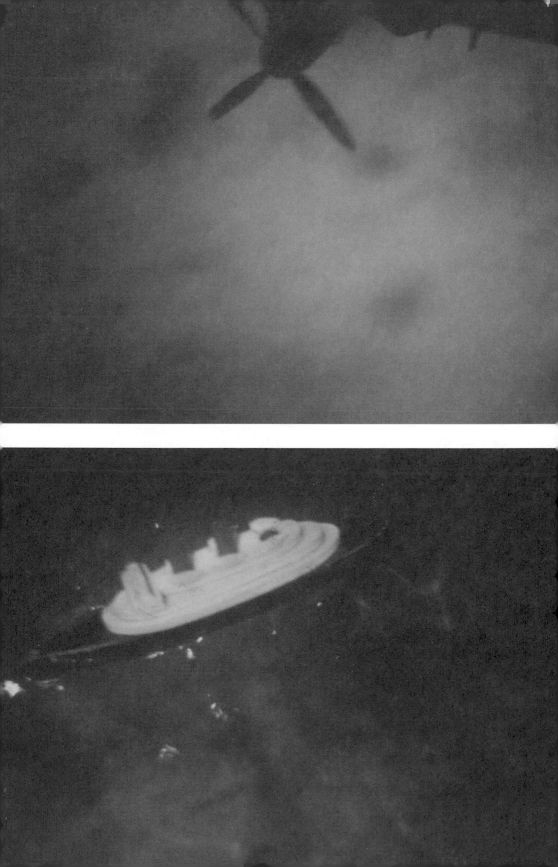

Karolina returned to Hamburg and began work in the bird sanctuary at the zoo. She loved the egrets and the peacocks, who would eat schnitzel and hamantaschen from her fingertips.

Within a few months, however, the government became increasingly concerned about the uncontrolled freedom of its more liberal scientists. Karolina became a political prisoner at Neuengamme, where she could be more carefully watched. She saw herself become a bird in a cage. Watched. Clipped. Crumbs.

George became a pilot in the Royal Air Force. He had the eyesight of a bluebird. His first days in the bomber plane were awkward and uncomfortable until he gradually began feeling his bones turn into aluminum and steel, and his body stretched out to fully inhabit the remarkable machine.

His moment of honor arrived at the very end of the war, when his commander ordered him to bomb the *Cap Arcona,* a luxury liner that had just set off for a voyage across the Baltic Sea, filled with escaping war criminals.

George's mission was to sink the *Cap Arcona* before it reached Helsinki.

In the reconnaissance photos, it is not entirely impossible to distinguish the political prisoners from Neuengamme: thin gray and white figures in uniforms of thin stripes of white and gray. They are standing among large crates of explosives, which the escaping war criminals planned to detonate shortly after their arrival in Helsinki.

From the deck of the *Cap Arcona*, Karolina saw the glorious airplanes descend through the clouds.

She waved to George.

He waved back to her from inside the cockpit of his airplane.

The bomb fell through the air between them.

To Karolina and George, it looked very much like an egg.

THE DOUBLE NAUTILUS

Deep below this city is a double nautilus of stone. A twinned mating of helix upon helix, their sloping tunnels sounding and resounding with a pale and somber echo that speaks of absence, longing, sorrow.

On the surface, there is little talk of it.

An iridescent place, halfway between deep night and dawn.

We know that all here once was ocean—this ancient soil a burial mound for the diluvians. And these—our sinuous pitched stone tunnels—perhaps some flung-out corpse of twinned crustacean within calcified shells whose inner meat was long since harvested for protein. A form now hollowed out and resonant with echo.

It was nearly morning when I put the cotton in my ears and began the long descent into the alabaster.

There is an archaic humor to the stone that still defies us.

The structure suggests to some that these chambers might have once met a physiological intent: been sacks or veins of bile or phlegm or melancholic fluid demanded by an organ of enigmatic purpose, contained within two subterranean beasts we no longer recognize or know.

Those were distant days, lit by a star that hung above like some bright lantern in an otherwise endless night.

The great Swiss lake stretched its wet along newly sewn seams of dirt, and pricks of green drank at it before edging themselves up the foothills.

Trees issuing forth from follicles on a newborn skin of earth, hairs sloughed off with each new layer.

And beneath it all, these sweet and stoic beasts, inhabiting their mated shells below our world.

Most contemporary scholars posit that across time, older, long-extinguished shadows of ourselves cut and clawed and hewed this refuge, then polished it, abandoned it, and moved on.

Perhaps these first peoples sought shelter in the depths. Perhaps an apocryphal event on the surface sent them downward for survival—perhaps hurricanes, or cyclones, or tornados.

Fires. Or freezes.

Perhaps devoted acolytes, long dead, drilled out these mathematical passages in service to some entity we no longer know to worship.

Others suggest that early human life-forms developed a primitive technique for mining a soft substance from the earth, and these coiled and tilted tunnels were canals for its extraction.

Less tedious early theories, once axiomatic, infer that this mined substance was in fact the flesh or inscrutable lymph of two enormous sea creatures that formerly dwelt within the shells.

The folktales say that once, very long ago, two sea creatures came into being deep below the Baltic Sea. They grew alongside one another, twisting and turning ever outward together in a meticulous southward calculus of movement.

As the eons passed, these amorous companions built layer upon layer of shell, melding together a solid, calcified spiraled membrane that separated yet structured them.

Their flesh was two. Their forms were one.

They were close to one another, yet far.

It was a strategy that supported growth and change without compromise or disunion.

They grew thicker and broader and stronger, and rose up ever closer to the surface of the earth, until one day, the two hooded openings reached light and the fleshy things—astonished and bewildered—knew no better than to unshell themselves and crawl and crouch and dream on the emergent strata of the planet.

They were unprepared for the sun.

They were unaccustomed to the light.

They were savaged by the separation, by the loss of structure and love and communion.

They became disoriented and lost: they had no means of navigation.

They cried out for each other, but had no ears.

They looked for each other, but were without eyes.

Their flesh crept and crept, but each could not find each.

One day, amid the sweat and silt of loss and longing, the creatures became lodged beneath the rise of an alpine mountain in a burrowing thrust of pain, crying out, *From here I do not know how to find you.*

And thus they perished, each alone on the rock, dying against the hard ridge of gneiss and granite.

Going down, one must fill the ears with cotton and bandage the eyes with gauze against this cryptic, nacreous half-light that can neither illuminate nor obscure.

I wonder: could the iridescence here be the source of trouble?

The nerves of my cornea, arrayed in logarithmic spiral, break down within this nautilus.

Perhaps it is the similarity of biologic architecture that causes destructive interference—a nest of spirals in the eye, with the impact of Medusa's tangled snakes: at first the sight grows dim, then begins to blur until a white night of opacity descends.

Mine is a visual madness.

This kind of light begs an eyelid's shuttered gaze.

When the vista ahead cannot be comprehended or believed.

I have come too far here—in this place, in this story—without answering the fundamental questions of how and why and when. I haven't asked them, and it's possible they don't exist.

Down here, there is only what is, and was, and perhaps will be.

It was late summer in Rome, and I had arrived in the lecture hall of the mathematics building—early, earnest, and half-hearted—to prepare for my lecture on spira mirabilis, Bernoulli, and Torricelli. I arranged the chairs in thin, long strips with few rows, somehow hoping this would settle my nerves. Averse to caffeine, I had taken several espressos, each with two cubes of ice: they arrived in my stomach with such abrasiveness that I wondered if I should soon give frictive birth to pearls.

I opened the windows to let in the damp air of early morning.

I was setting a prospectus on each chair. It contained my credentials, my area of specialization in the spirals of Theodorus and Fermat, of Archimedes and Euler and lituus and Cornu.

The light streamed into the room from the north.

She entered, a stern and curious assemblage of spectacle and movement and intent.

There are hawks whose bodies hunt in similar equations. Their success is calibrated on a commanding pitch of directional flight, a calculated angle of descent.

The alpine borderlands of Italy, our twists of road and perched rock structures—the softness of our soil was never more than a false promise, for below it all is rock and fundament.

Along some distance, the road follows the enormous twisted corpus of these spiraled beings, these half-mined husks that came to grow around their flesh. Their annulated chambers whorl beneath the Alps, the high lands near Athens, and into the blackened, angry forests of the Slavs before vanishing deep below the flatlands at the Baltic Sea.

Amidst this rise of mountain that forms the creatures' crests? The bronchial lung of the particle collider, and its quantum mysteries of matter.

These were the early days of the particle collider, and the geology of its future home was under scrutiny. Because of the structural engineering research for this multinational enterprise, contemporary scientific inquiry surrounding the origin and structure of our nautilus was briefly reinvigorated.

Its possibilities ignited a tide of curiosity that promised to raise all ships.

Project funds, peer-reviewed articles—anything seemed possible.

She had arrived in Rome seeking resources for her own investigations. As she told me, here was her best opportunity to secure long-awaited funding of a subterranean expedition into the enigmatic tunnels of the double-helix nautilus.

She told me of her work each day. Assembling her equipment, her instruments, and all necessary apparatuses.

She was trained as a geologist. In her years above, she established a significant reputation for clearheaded logic surrounding the sort of problems that accumulated arthritis in the joints of learning: old, erroneous theories within earth sciences that had long been suspect or proven wrong, yet still radiated a nimbus of incorrectness that somehow hung over the enigma and thickened, obscuring the path toward new knowledge.

She became known for her ability to penetrate this fog of ignorance and construct a membrane from which she would announce new and startlingly simple approaches that had long defied the most highly regarded minds.

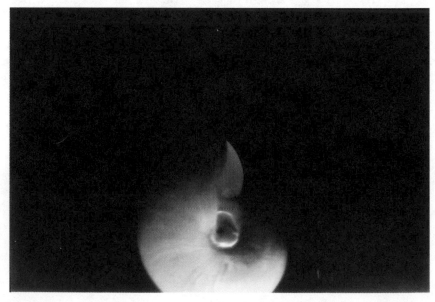

As her career quietly advanced, this ceased to be an asset. Resentments grew, and the field around her quickened with whispered anecdotes concerning her near-mythic ability to demolish her peers' proprietary hypotheses moments before their appointment at the tenure review committee.

She became legendary, and unwanted.

The old wooden doors of earth science academia closed in and snubbed her innovations.

It was then that she began fundraising for her expedition to the cavernous tunnels that have forever underpinned our city.

Her apartment was near mine. After my lecture, she walked me home, and vanished into the alleys of the old city.

I hoped she would appear again, and she did.

There were at first long afternoons walking the ghettos of Rome together, only half-aware of our surroundings, pausing to pick up stones from the roadside and tumble them in our hands, and look at leaves and tear up tiny pieces of ticket stub and rail pass as the ideas circulated. Nervous, unnerved, we shared secret enthusiasms, we noted the temperature of the light, and we shyly paced together in long, skeletal strides across the cobblestones.

We were as uneven as the cobbled rocks, and excited. There was a scientific response between us that was chemical and biological.

We quivered and shook, and our neurons rose up in a spectacular array.

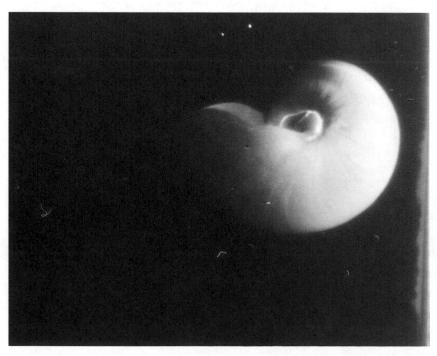

As a geologist, she approached each strata of her suitor: my skin, then the adipose tissue, then the muscle, bone, and marrow.

A thigh became a cliff.

An abdomen a mineral morass.

I hoped she would learn my form as though it were the only land worth knowing. That she would plumb deeper in search of clues to what events preceded our common era. I knew she could ascertain of what I am composed, and the process by which I evolve.

She could predict my hazards and understand my movements, my patterns of erosion and deposition.

She drew me out, and in.

Later, there were late nights when she stayed talking with me until dawn, and I longed for the soft sound of floss between her teeth that would remind me to go into the bathroom and pull her back to bed before she could remove the taste of seashore from her mouth.

Yet that desire was fantasy: the only exchange between us was in words—no erotic fluids built by body to blend soul.

Instead, she critiqued my publications, and I checked all her equations.

There were rare moments in which I could look at her while her head was turned, and I wished to run my fingers along the channels of stretched flesh below her breasts, across her slip of nose, her stabile and confident armature of bones that arrayed themselves in her delicate jawline, shoulder, hip.

We were a continent of want, all flesh and blood and brain.

There were tears in my eyes when she first took my hand in her long rock fingers, hard and smooth and fully charged with a cool pull that felt governed by fundamental laws of nature.

I do not weep, but my liquid salts dislodged from the charge of her electricity.

The sturdy flat plates of her fingernails suggested the grip of some entirely other entity: a reaching, grasping thing that came for me and held and then let go.

After several months had passed, I found her name referenced on a poster for a scholarly symposium at the university.

I wore my best suit and took a seat at the back of the hall.

The speaker claimed to be a former member of her team. He suggested that eighteen years previous, my geologist had embarked into the nautilus as the director of a well-equipped, highly funded team of scientists. In the subsequent ten years, each of the other scientists returned to the surface one by one—each of them astonished to learn she had not already surfaced.

Eight years, he said, *have now passed without any trace of her existence.*

I knew he was an imposter, and apocryphal: I had met her only months before, when she was as yet seeking funds for her expedition.

I attended occasional and increasingly obscure symposia, each led by her purported former team members. Each claimed to have quickly lost sight of the others below the surface, and thought they had been alone down there in the cold and dark. Each described a harrowing experience of disorientation: key equipment no longer functioning, incorrect instrument readings, settings that defied calibration, the compass needle that spun and spun without pausing to point north.

One by one, her team secured modest positions of authority within structures of society and intellect and culture, and made their mark there, without her. As though she had never existed on the surface at all. She became a legend, and I, unwillingly fooled by false belief, her sole adherent.

I located the remaining members of her party. I traveled to Athens, to Naples, to Vilnius, to Cambridge, to Copenhagen. I sat down with them, and described in great detail the time I spent with her in Rome: how we walked and talked of her plans for the journey below, the cogent questions she asked following my lecture, the delicacy of her small ears, the odd accent in her voice, the structural schemata she carried with her and spread out across my breakfast table. I shared with them my consternation when she vanished—that I'd thought there were months yet to go before her descent, that we would have time.

I asked if they had clues to her coordinates. Where and how I could find her.

And each by each, they bent their heads to examine the date on my tattered flyer for the Bernoulli lecture, and they pronounced— apologetically yet with certainty—that she was already far inside the nautilus at that time.

It is impossible that she attended your lecture, they said. *The years are all wrong. It must have been some other woman. You are mistaken. It is simply not possible.*

That was their attempt at kindness, because what they wanted to say was far worse: that I am not grounded in reality.

That I am mad, or sick, or deluded.

The calculations are all wrong. The coffees, and the conversations, and the dreams of dental floss and lovemaking are equally chronologically impossible. I was simply lost in Rome. And I was alone.

Above, there is a fireman who made me a pack with sturdy shoes and a blanket. He was trained in rescue missions. He was the one to lace up and buckle my shoes, because he believed I was unlikely to do it—like so much else—in the calm, rational way that would ensure their safe and proper functioning.

The fireman said my danger would come in suffocation, in crushing, in collapse.

Like me, the fireman spends his surface time in grief and confusion.

The fireman had knots of dark curls, and muscles for lips that talked to me of resolve and fortitude and calm in the face of certain defeat. His forehead displayed the disrupted fascia of his soul, which knotted up each time someone was lost, burned—at times charred only in sections, so that a finger remained pristine, moist.

His is a battle with water, more than heat: he said my battle was more difficult.

The fireman said that many who are never rescued long to be. He said that many who are saved had been hoping not to live.

That sometimes it is the rescuer who winds up needing to be saved.

These homilies did not speak to me. I told him nothing of my time with her. What she provoked within the most distant reaches of my being he could no more accurately hear than see.

I told him only that she had gone below, and I must follow.

I first entered the tunnel of the nautilus in an early autumn so subtle it seemed like summer, and it became the cusp of winter while I was down below.

Along the first miles, sodium lights are strung in orderly, looping arcs of wire that say, *Here we have command over what's seen, and what is not.*

Here we mark our way.

Here we chart our path.

By deep winter, I was down where wires did not reach—but no matter. At a certain depth, the structure takes on a half-sentient bioluminescence. There is a rise and fall to the light here that suggests a dawn and dusk.

It comes with a rosy gold of lamplight, like a candle glowing through a lung.

Let me first tell of how I sleep and wake on my journeys down here, when I lie alone in soft rubber shoes, listening for any sound of her. I have not found her, and yet I feel so close to her I wake singing to her, only to realize the chamber remains empty.

This love a paradox.

When I dream it is of her teeth, and the gap between the two that parts like ancient gates, suggesting an arrival that might come tomorrow. Never. Always.

I dream of her, and my back is worn to aching from arching my spine along this empty shell. I put my hand to my hard places and rub and rub and rub, as though she rides atop me, and I am torn and sore from it.

Waking, I run my hand against the stone and know it pulls me deeper down.

Some mornings, I wake down here with bruises that cannot be explained. At times they encircle my body in a logarithmic array.

As the height of the chambers lowers, I find myself on my hands and knees, and the luster of this shell seems more her skin than stone.

There is a seashell scent to it, and I dip my mouth to lick its sheen as though the hollows of her hips narrow to define a place where I can extract some nourishment.

My tongue leaves a trail of saliva along her length, stretching for miles upon miles of endless need.

The sheen of this place seems a kind of membrane, as though a thin layer of mineral oils lubricates its surface, and now I feel this chamber is instead a corridor, a canal, a means of passage, for what I cannot say.

Closer to the surface, there were, in places, the delicate droppings of bats against the pale stone, and occasionally a crumpled filigree of bones, all desiccated cartilage and broken wings, encrusted with crystalline prisms of mineral.

At first, it seemed the sound of crickets followed me here. Cicadas from the meadows dry and cracked above. There are soft sounds and crisp ones, muffled clips and taps and thuds and bangs.

In the months ahead, as I traced the whorled channel of white rock more deeply into the earth, I realized the sounds did not issue from inside the chamber, but from without.

Today, I pressed my ear to the flesh of the earth and heard these noises at close distance. These sounds are her breath and footsteps, her harvesting of nourishing salts from the walls, her equipment, her sensors and devices.

She is in the other helix, the spiraled twin that slips against my own.

I now sleep with my eyes pressed against the stone, as though I have become a moth, and through these walls I can sense her light.

Or she, mine.

But she maps my shadows with her equipment, and then moves on.

I follow.

It is more narrow here. I spent the first span of time upright, walking toward her. Then crouched, then crawling.

Since I heard her breathing in the twin spiral alongside me, I have crept on my belly, letting my flesh scrape against the walls that have gone from tunnels to tubes.

We are so close that it is no longer cold. The alabaster seems at times to define a nipple.

A black triangle patch of fur that glides along next to me, as though I could stretch out my red tongue like a serpent and taste her.

Always, though, there is the wall.

I have begun to get slimmer, and to faint. I pass out in the tunnel and wake thinking the shell is my skin: I shudder against it with rhythmic seizures of neurological contraction and expansion.

Her heart beats in her ankles, and at times she sleeps with them pressed to my kidneys and rump.

The pulse of her quiet and determined, etheric in the depths.

I whisper my equations to her: they are orderly, and balanced.

She knows this, and replies with the chemical formulas for salt, for devotion, for intimate confession.

These are a tapestry of numbers and letters that she wraps around me, and they shine in the darkness: everything can be controlled here, through patterns and structure.

Now, here, near the base of the spiral, each in our tunnel, I speak to her lips with my lips: we are that close. The shell is thin. I can sense the steam from her breath.

I ask her why she left me up above.

She said she never surfaced, she says we never met. She says she has been down here always.

She said she has dreamed of finding the end of the spiral.

She said this is the culmination of her theories and research: that at the base, she would make a discovery.

She would find the other being.

Again, I have fainted. When I wake, it is to the sound of tapping. Everything is darkness, and there is the sound of seagulls. The tunnels are full of salt water, and I cannot breathe.

I see her on the other side. She is long and narrow, like me, with eyes made enormous by the dark. We are smiling. We have lost our clothes in the higher chambers.

Our nails have grown long as claws.

She has a bone in her finger—it is her finger bone.

She is tapping at the shell.

The barrier is so thin. I am clawing at the shell. I strike it with my forehead—the broad expanse of pale skull from which my dark hair recedes and now I know why: it was needed for this, for this breaking.

We have reached the point at the base of the whorl. The two nautiluses meet at the aperture of us. We are below the sea, below everything. We are subterranean tunnel lovers, and the single shell now contains us both, with no membrane in between. The divergent boundary, reversed. Self-congruent.

She says this has been here all this time. That we merely needed the strength to go deep enough.

This, then, is the formula for happiness:

To start at the same plane of axis and wrap around that point in a circular pattern. To follow a curve on a slope. To wind with it, lost and alone, around a fixed center point at a continuously increasing distance from the point.

To feel you are at all times in error.

To turn back. To retrace your steps. To seek decreasing distance from the point of her. To become dizzy and lose consciousness from lack of air and light and heat.

To take off all your clothes and lie there, crying.

Believe that she does not exist. That you have become a madman.

And then arrive at that point, at the binding site, and find her there.

NOTES ON METHODOLOGY

All the pieces in this collection were created at sites in the Baltic, New York, and California that have held unique histories during many wars. At these sites, I worked with salvaged military typewriters and broken film cameras manufactured by slave labor during fascist dictatorships.

Everything in the photographs is achieved in-camera, through old-fashioned mechanical and optical and chemical means—the colors, textures, shapes, and multiple layers in the photographs are all created using only the unique aberrations of the cameras' optics and the chemistry of the film. The negatives are scanned and printed without digital manipulation. When working with an 80- or 100-year-old camera filled with rust, dirt, cracks, and battlefield detritus, each responds uniquely to the film, light, and lenses—most of their calibrations aren't standardized. It takes a tremendous amount of time to build a sufficient working relationship with each camera to produce even one image. This level of obsession is a good way to learn how to watch how the world glows.

The Cartographer's Khorovod

The khorovod is an incantatory, ritual story, song, and dance that unfolds in a round or spiral form. Typically led by women, its origin lies in ancient pagan rituals of courtship, attraction, and romantic negotiation. The dancers stand in a circle that represents the solar disk and move from east to west following the sun's path across the sky. As Vadim Prokhorov wrote, "Structurally, the melodies of khorovod songs . . . most often consist of two dissimilar, contrasting, question-and-answer-type phrases, creating different types of the binary form." The photographs for this story were created at two sites: the coastal forests of the Baltic and Germany, where Nazi tank fortifications and mass graves still remain, and the Adirondack forest battlegrounds of the

Revolutionary War, where a group of Hessian mercenaries suddenly switched sides to fight for the revolutionaries. Special thanks to Niklas Derouche.

Aurora and the Storm

This story was written while stranded at a remote Hudson Valley inn during Hurricane Irene and during a physics conference at a former Nazi resort hotel in northern Norway. The photographs were created at the Overlook Mountain House—a luxurious, ruined pleasure palace that was built during the nineteenth century and later burned nearly to the ground. Special thanks to Megan Cump and Stacey Steers.

The Anguillidae Eater

The Anguillidae Eater inhabits the Curonian Spit of Lithuania—a tiny spit of land in the Baltic Sea where ancient and ferocious female deities are still known to roam. Over the centuries, their mystical, cryptic seaside has been invaded by Vikings, Russians, Catholics, and Nazis—each wanting to plunder, subdue, and control this disconcertingly female ensorcelled slice of earth. Yet, the Anguillidae eels journey for ten long years from the Sargasso Sea just to mate in these icy, enchanted waters. I became very intrigued by the line between erotic exploitation and erotic satisfaction: what pleasures and pains emerge within the complex power negotiations between woman and man, human and animal, hunting and harvest, giving and taking. The photographs for this story were created at the Cormorants Colony of Juodkrantė on the Curonian Spit, at sites of mass animal slaughter along California's Point Dume/Paradise Cove (where thousands of California gray whales were harpooned, lanced to death, and flensed into oil), and at New York's Barren Island bone heaps (where the bodies of New York City's carriage horses were rendered into glues and fertilizers). Special thanks to Eimutis Juzeliūnas, Veronika Krausas, Nora Maynard, and Patrick Horner.

287

Holdfast Crowbiter

On the Curonian Spit of Lithuania, the constantly shifting sand dunes made agriculture a perilous occupation—entire villages would sometimes vanish under the dunes, where they would be lost forever. The land itself was under constant occupation and invasion by Vikings, Nazis, and Russians, and war brought further famine and hunger. Any source of food was precious. Until the twentieth century, men would trap crows with nets and kill them with a single bite to the neck. But invasion and war took many of these men far from home. For the women who had to step up and make a sacrifice of the sacred crows, the taste of salt in the mouth is not unlike that of blood. Photographs were created at Nerida, Lithuania, and Barren Island, Brooklyn.

My Nebulae, My Antilles

This story was written in the Antilles, in between travels to Latvia, as a study in time travel inspired by the ideologically based travel constrictions of the Communist era and the timespace-based travel constrictions of Newtonian physics. The lonely, existential liberties of airmail unfolded within an apocryphal story I was told about mail being dumped in the rivers and oceans of Latvia during Soviet times, alongside the migratory paths of the Anguillidae eels, which are born in the Sargasso Sea, migrate to the Baltic, and follow a deep-water trench back to the Sargasso, where they arrive to spawn. It took thousands of years for humans to realize that the eels of the Baltic and those of the Sargasso were the same creatures a lifetime apart. The photographs were created at a decommissioned Soviet-era paper factory in Latvia on the coastal road outside Riga.

The Kholodnaya Voina Club *for Lt. Kent Edward Koontz*

A. K. A. "The Cold War Club." The photographs were created at Floyd Bennett Airfield in Brooklyn, where salvaged military warplanes are rehabilitated by a team of volunteers with the HARP project. Special thanks to Matthew Contos.

On the Sofa in Vilnius

I once met an elderly Jewish Lithuanian woman who spoke of her life in Lithuania before the war and the Shoah. As a young woman of twenty, she trained as a seamstress and opened her own shop, selling what she described as "menswear for women." These were for informal, private gatherings of women who did not wish to wear dresses or skirts. They loved her clothing. She said that as a result, she became socially unacceptable and was encouraged to move to Paris—the arrival of war merely hastened her departure. But, she said, there was a woman, beloved, closer to her than a sister, who at the last moment did not join her. She had been a cleaning lady at a synagogue, and she did not survive. In Paris, after the war, she opened her own atelier, where she continued her line of clothing for women who wished to dress as men.

The Delicate Architecture of Our Galaxy *for Julia and John Wikswo*

My Lithuanian grandfather was a chemist for the Manhattan Project, as well as an avid pickle maker. In his later years working in rural Virginia, his habit expanded to include traditional Southern delicacies like pickled watermelon. After he died, we began to empty his farmhouse and came upon many large pickle containers with broken lids—in the summer heat, their stench confirmed what we suspected. All manner of small and furry creatures had gone hunting in the pickle jar and, inadvertently, had become pickles themselves. I've been making these photographs through experiments with blue-glass optics, which is to say, photographing through the surface and contents of old blue mason jars. The photographs for this project were created at the lakes of Yaddo, which Katrina Trask named after her dead children and used as sites for ritual, pilgrimage, and meditation on love.

Cap Arcona *for Paetrick Schmidt*

The *Cap Arcona* was a German luxury cruise liner that sailed the Baltic Sea in the 1930s. In April 1945, the final days of WWII, the Germans

requisitioned the ship and filled it with escaping Nazi war criminals and prisoners from evacuated concentration camps. It set sail for Helsinki, where the Nazis planned to disembark and then dynamite the vessel, killing all the prisoners. On May 3, it was bombed and sunk by the British Royal Air Force (RAF), and the majority aboard drowned. Bones from the concentration-camp prisoners washed up on the Baltic shore well into the 1970s. The RAF officer who gave the bombing orders later disappeared while flying an alleged Nazi ratline over the Bermuda Triangle. The photographs were taken at the Prison Ship Martyrs Monument in Fort Greene, Brooklyn—where the bodies of Revolutionary War patriots were buried after dying on British prison ships anchored in the East River—and at Floyd Bennett Airfield in Brooklyn, where warplanes embarked on bombing missions across the Atlantic throughout WWII. Special thanks to Paetrick Schmidt and Matthew Contos.

The Double Nautilus *for Matthew Contos*

My mathematician grandmother and her geologist sister both worked on the Manhattan Project in New York, where they explored one of the great mysteries. For the first five years of my life, I played above, alongside, and within the tunnels of the Stanford linear particle accelerator; in later years, I spent time at CERN during the construction of the Large Hadron Collider, where dark-matter physicists introduced me to the emerging corridors and tunnels beneath the Alps. Special thanks to Matthew Contos.

ACKNOWLEDGMENTS

A coast is a site where sea meets shore, and both are transformed by the encounter. The creation of this book occurred over many thousands of miles of coastline in the Baltic, New York, and California. There were many seas and many shores, and I am grateful for the many ineffable transmutations along the way.

I am profoundly indebted to the timespace of Yaddo, especially Elaina Richardson, Candace Wait, Sean Marshall, Michael Hazard, and all the errant troublemakers with whom I lived and worked. Without Yaddo, this book would not exist. A deep bow to my transmogrifying Creative Capital family, including Ruby Lerner, Sean Elwood, Merle Augustin, Lisa Dent, and Ethan Nosowsky. To my tender, lionhearted agent, Kent Wolf, at Lippincott Massie McQuilkin, and to the ferocious shepherds of my work at Coffee House Press: Anitra Budd, Chris Fischbach, Molly Fuller, Caroline Casey, Amelia Foster, and the wondrous Allan Kornblum. May his memory be a blessing.

I would like to thank my family for their intrepid laboratory partnership on this enigmatic experiment: Julia Wikswo, John Wikswo, Stacy Flood, Eric Grush, William Gross, Susan Martin, Leonora Wikswo, Spydre and Rü, Mukanday-if-by-Sea, Avishai-the-Sublime, and the wee daemon Onophría Ixtlan.

The book itself wishes to acknowledge the n-dimensional involvement of Niklas Derouche, Katrina Trask (May 30, 1853–January 8, 1922), Jacobus Barhydt (February 9, 1753–December 22, 1841), Matthew Contos, Nicky Giesler, Lieutenant Kent Edward Koontz, u.s. Navy (October 28, 1968–March 6, 1998), and Dr. Robin Kilson (May 31, 1953–April 29, 2009), who instructed me to leave Texas, write a book, and always keep a case of champagne in the trunk of the car.

I am grateful for the constellation of bright stars on the navigational team who, in nine different countries, collaborated with, assisted, advised, and contributed to the projects in fieldwork, studio work, performances, and to the fabrication of this book. An infinitely extending gratitude to Eimitus Juzeliūnas, Paetrick Schmidt, Veronika Krausas, Zachary Levine, Nora Maynard, and Kristofor Giordano. Deep appreciation to Joost Baars, Grayling Bauer, Astrid Beigel, Amber Berman, Alessandra Castellanos, G. K. Callahan, Maxine Chernoff, Mike Chou, Sarah Clark, Andrea Clearfield, Matthew Contos, Megan Cump, Sarah Dohrmann, Craig Foltz, Lynn Freed, Bailey Grey, Eric Grush, Heather Harstad, Dorothea Herreiner, Patrick Horner, James Ilgenfritz, Jaime de la Jara, Mitch Kamin, Arthur Kell, Dan Kern, Anne Le Berge, Daniel Levenstein, Rafael Liebich, Velinda Mackey, Pamela Madsen, Risa Mickenberg, Terrell Moore, Tomáš Panyrek, Alexx Shilling, Guru Singh Khalsa, Ranbir Singh Sidhu, Susan Silas, Stacey Steers, Samantha Stiers, Mackerrow Talcott, Alys Venable, Shelton Walsmith, Helen Wan, John Wikswo, Erin Wilcox, Mike Wiley, and to the many denizens of Cabaret Q in San Francisco, Comrade Truebridge's and Flashpoint in New York City, and Catalysis Projects and Fieldshift Further in Los Angeles. Lastly but not leastly, a tip of the helmet to Bob Riggins, who painstakingly fabricated all of the airplanes for this book from deep in the heart of Texas.

Thank you to the many institutions that provided mooring, anchorage, and rat-wrangling during this voyage: Yaddo, Creative Capital, Colleen Keegan of the Theo Westenberger Estate, the Pollock-Krasner Foundation, Bin Ramke at *Denver Quarterly,* Rob Spillman at *Tin House,* the Puffin Foundation, the Center for Cultural Innovation, Byrdcliffe Colony, Oberpfälzer Künstlerhaus, Ebenböckhaus and Thomas Linsmeier, the Millay Colony, Ucross Foundation, the Virginia Center for the Creative Arts, Ragdale, Montalvo Arts Center, Schloss Pluschow, the Museum of Jurassic Technology, Beyond Baroque, Zachary Levine

of the Yeshiva University Museum, and Joanne Jacobson and Joy Ladin of Yeshiva University.

And to the sites themselves, a very special gratitude to Karma Triyana Dharmachakra; Floyd Bennett Field, Hangar B, and the Historic Aircraft Restoration Project (HARP); Vittorio Palmieri at the European Organization for Nuclear Research (CERN) and the Large Hadron Collider; and Keivan G. Stassun, the Apache Point Observatory, and the Sloan Digital Sky Survey. And my love to the Baltic, the Curonian Spit, the Rossitten Bird Observatory, the Cormorants Colony of Juodkrantė, and the Kuršių Nerija National Park of Lithuania.

FUNDER ACKNOWLEDGMENTS

Coffee House Press is an independent, nonprofit literary publisher. All of our books, including the one in your hands, are made possible through the generous support of grants and donations from corporate giving programs, state and federal support, family foundations, and the many individuals that believe in the transformational power of literature.

We receive major operating support from Amazon, the Bush Foundation, the McKnight Foundation, and Target. This activity is made possible by the voters of Minnesota through a Minnesota State Arts Board Operating Support grant, thanks to a legislative appropriation from the arts and cultural heritage fund. Our publishing program is supported in part by an award from the National Endowment for the Arts. To find out more about how NEA grants impact individuals and communities, visit www.arts.gov. Support for this title was received through special project support from a Jerome Foundation 50th Anniversary Grant.

Coffee House Press receives additional support from many anonymous donors; the Alexander Family Fund; the Archer Bondarenko Munificence Fund; the Elmer L. & Eleanor J. Andersen Foundation; the David & Mary Anderson Family Foundation; the Patrick & Aimee Butler Family Foundation; the Buuck Family Foundation; the Carolyn Foundation; Dorsey & Whitney Foundation; Fredrikson & Byron, P.A.; the Lenfestey Family Foundation; the Mead Witter Foundation; the Schwab Charitable Fund; Schwegman, Lundberg & Woessner, P.A.; Penguin Group; the Private Client Reserve of US Bank; VSA Minnesota for the Metropolitan Regional Arts Council; the Archie D. & Bertha H. Walker Foundation; the Wells Fargo Foundation of Minnesota; and the Woessner Freeman Family Foundation.

THE PUBLISHER'S CIRCLE OF COFFEE HOUSE PRESS

Publisher's Circle members make significant contributions to Coffee House Press's annual giving campaign. Understanding that a strong financial base is necessary for the press to meet the challenges and opportunities that arise each year, this group plays a crucial part in the success of our mission.

Publisher's Circle members include: many anonymous donors, Mr. & Mrs. Rand L. Alexander, Suzanne Allen, Patricia Beithon, Bill Berkson & Connie Lewallen, Robert & Gail Buuck, Claire Casey, Louise Copeland, Jane Dalrymple-Hollo, Mary Ebert & Paul Stembler, Chris Fischbach & Katie Dublinski, Katharine Freeman, Sally French, Jocelyn Hale & Glenn Miller, Jeffrey Hom, Kenneth & Susan Kahn, Kenneth Koch Literary Estate, Stephen & Isabel Keating, Allan & Cinda Kornblum, Leslie Larson Maheras, Jim & Susan Lenfestey, Sarah Lutman & Rob Rudolph, Carol & Aaron Mack, George Mack, Joshua Mack, Gillian McCain, Mary & Malcolm McDermid, Sjur Midness & Briar Andresen, Peter Nelson & Jennifer Swenson, Marc Porter & James Hennessy, E. Thomas Binger & Rebecca Rand Fund of the Minneapolis Foundation, the Rehael Fund-Roger Hale & Nor Hall of the Minneapolis Foundation, Jeffrey Sugerman & Sarah Schultz, Nan Swid, Patricia Tilton, Stu Wilson & Melissa Barker, Warren D. Woessner & Iris C. Freeman, and Margaret & Angus Wurtele.

For more information about the Publisher's Circle and other ways to support Coffee House Press books, authors, and activities, please visit www.coffeehousepress.org/support or contact us at: info@coffeehousepress.org.

Allan Kornblum, 1949-2014

Vision is about looking at the world and seeing not what it is, but what it could be. Allan Kornblum's vision and leadership created Coffee House Press. To celebrate his legacy, every book we publish in 2015 will be in his memory.

COLOPHON

The Hope of Floating Has Carried Us This Far was designed at Coffee House Press, in the historic Grain Belt Brewery's Bottling House near downtown Minneapolis. The text is set in Bembo with Brandon Grotesque titles.